IMAGES
of America
WAIKĪKĪ

Kai White and Jim Kraus

ARCADIA
PUBLISHING

Published by Arcadia Publishing
Charleston SC, Chicago IL, Portsmouth NH, San Francisco CA

Printed in the United States of America

Library of Congress Catalog Card Number: 2006938511

For all general information contact Arcadia Publishing at:
Telephone 843-853-2070
Fax 843-853-0044
E-mail sales@arcadiapublishing.com
For customer service and orders:
Toll-Free 1-888-313-2665

Visit us on the Internet at www.arcadiapublishing.com

To our daughters:
Clara, who first played in the ocean at Waikīkī,
and Carolyn, who was born there

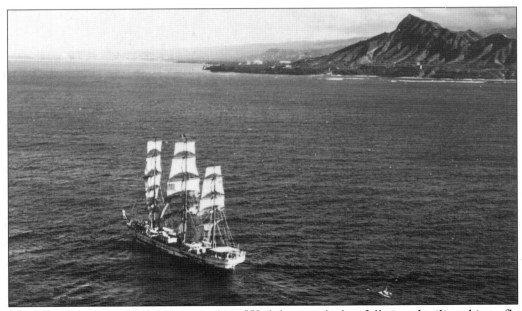

The *Tusitala*, pictured in 1920 approaching Waikīkī, was the last full-rigged sailing ship to fly the American flag. Built in Scotland in 1883, *Tusitala* is also the Samoan word for storyteller and was the name given to Scottish writer Robert Louis Stevenson, who made extended visits to Waikīkī. (Courtesy Hawaiian Collection, University of Hawaiʻi Hamilton Library.)

CONTENTS

ACKNOWLEDGMENTS

Our special thanks goes to the staff of the Hawai'i State Archives for their patience, especially Vicky Nihi and Mele Leota. We also extend our thanks to Judith Bowman of U.S. Army Museum of Hawai'i for images from her collection.

A unique group of photographs and stories came from the Center for Oral History at the University of Hawai'i at Mānoa. For these, we give our thanks to the director of the Center for Oral History, Warren Nishimoto. Also at the University of Hawai'i, in the Hawaiian Collection of Hamilton Library, Stu Dawrs and Dore Minatodani were of immense assistance, so we extend our thanks to them. For photographs of Waikīkī in the 1950s, we thank Kiersten Faulkner and Scott Cheever of the Historic Hawai'i Foundation. Thanks also to Todd Presley and Henry Wolter in the Honolulu office of the U.S. Geologic Survey for their advice, as well as for access to maps and photographs. We thank Al Lum for steering us toward the Bertram Collection at the Hawai'i State Archives and Paul Dolan for his photographs, stories, and corrections.

We want to express our gratitude for a research grant from Hawai'i Council for the Humanities; a special thanks to Bob Buss and Grace Lo for helping shape our thinking about the humanities questions involved in our work on this project. Thanks also goes to Mark Heckman and Carlos Chang of the Waikīkī Aquarium, as well as to members of the Kapi'olani Park Preservation Society. Also to the Chaminade University Humanities Division, David Coleman, and other staff—Dean McGinnis, Betty Sam, Cassandra Sakamoto, Tiffany Palmer, and Virhel Barrera. Our thanks go to Heather Maggini-McKay, Kate Lynch, and Lisa Castle, and to the librarians at Chaminade's Sullivan Library, particularly to Valerie Coleman, humanities specialist, and Puanani Akaka, Hawaiian studies specialist.

Special thanks go to individuals in our network of friends and mentors, including Keola Awong, Bill Chapman, Tom Coffman, Jack Gilmar, Mark Helbling, James and Lois Horton, Robert Perkinson, Kieko Matteson, Sean McNamara, Tino Ramirez, David Stannard, and John White.

A number of others supported us in this project with their advice, encouragement, and sometimes childcare for our three-year-old daughter Clara: again, Robert and Kieko, Heather Barton, Gwen and Michael Cruise, and especially Rachel.

To these, and to others we have no doubt failed to mention, we give a heartfelt *mahalo nui loa.* We take full responsibility for any errors in our telling of the story of Waikīkī.

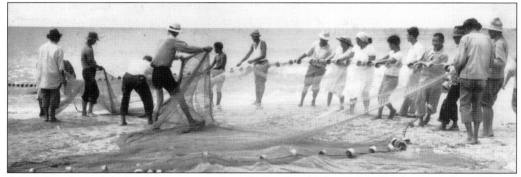

A *hukilau,* shown here, is a coming together of a family of fishermen to haul in a net from the sea. A common fish caught in this way was the *opelu,* a type of mackerel. Traditionally a family would feed the fish for several months before harvesting. (Courtesy Hawaiian Collection, University of Hawai'i Hamilton Library.)

INTRODUCTION

Waikīkī, literally "spouting water," is the name early Hawaiians gave the fertile area on the southeastern side of the island of Oʻahu. It probably referred to the freshwater springs located in the region or the three mountain streams that met the sea along Waikīkī's shores.

The geological origin of Waikīkī dates back to two million years ago, when the island of Oʻahu consisted of a single vast volcano. The highest points of this volcano were the peaks we now call Kōnāhuanui. The area now known as Waikīkī began as an erosional field on the leeward slope of this volcano. Perhaps 100,000 years ago, a group of secondary eruptions created the present landscape. The most dramatic of these secondary eruptions was the explosive arrival of Lēʻahi, known today as Diamond Head.

Although the earliest radiocarbon dating in Waikīkī is 1100 AD, the earliest settlers in Waikīkī likely came from older settlements in the Waimānalo, Kailua, and Kāneʻohe areas around 600 AD. Over the course of its 1,400-year history prior to European contact, Hawaiian culture transformed from a society of separate, self-sustaining ʻohana to a semi-feudal system of aliʻi (chiefs) and makaʻāinana (commoners).

Under the Hawaiians, the traditional ahupuaʻa (mountain-to-sea land division) of Waikīkī included both Mānoa Valley and Pālolo Valley. The watershed of these valleys provided abundant sources of water to the estuarial network of streams, marshes, ponds, and springs in the Waikīkī ahupuaʻa.

In the 15th century, Maʻilikūkahi, the nui, or ruling chief, of Oʻahu, moved to Waikīkī, likely because of its abundance of food and water, as well as its excellent surfing conditions. For the next 400 years, Waikīkī remained the seat of power for Oʻahu. Also in the 15th century, Waikīkī became the home of high chief Kalamakua, whom historian George Kanahele believes was responsible for developing the extensive irrigation system that supported several hundred acres of taro fields and fish ponds. Kalamakua was also known to enjoy surfing, especially at Kahaloa (literally, "long place"), near the mouth of the ʻApuakēhau Stream (the same stretch of beach shown on the cover of this book).

Over the centuries, Hawaiians built numerous heiau (temples, or sacred sites) in Waikīkī, two of them near the mouth of ʻApuakēhau Stream. Heiau were usually dedicated to specific gods, and some were used specifically for human sacrifice.

Periodically, chiefs from Maui, Hawaiʻi, or Molokaʻi would attempt invasions of Oʻahu, but until the late 18th century, the invasions failed. After one such failed invasion, the body of slain Maui king Kauhiakama was taken to a heiau at ʻApuakēhau for ritual sacrifice. Then in 1783, Maui king Kahekili, a descendant of Kauhiakama, successfully invaded Oʻahu, landing his fleet of canoes and warriors at Waikīkī. Because it was at ʻApuakēhau that one of his ancestors had been sacrificed, Kahekili hunted down and killed all of the Oʻahu chiefs and many of the inhabitants of Waikīkī; he also sacrificed Oʻahu king Kahahana at the same heiau. Kahekili died in Waikīkī in 1794. In 1810, the struggle for dominance among chiefs came to an end when the islands were finally united by King Kamehameha I.

Capt. James Cook's 1778 visit to Hawaiʻi, along with subsequent visits by other Western ships, resulted in the introduction of foreign diseases like syphilis, measles, and typhoid, which in turn resulted in a massive and rapid decrease in the indigenous Hawaiian population. Prior to the arrival of Cook, the population of the Hawaiian Islands was perhaps as high as 800,000. By 1832, when the first census was taken, the population of native Hawaiians was 130,000.

Although Captain Cook never visited Waikīkī, his protégé, George Vancouver, did. In 1792, Vancouver, as captain of the Discovery, was impressed by the advanced agriculture of the Hawaiians. Vancouver gave this description of being taken ashore by Hawaiians: "This opened

to our view a spacious plain, which had the appearance of the open common fields in England; but . . . divided into fields of irregular shape and figure in a very high state of cultivation, mostly under immediate crops of taro."

In the mid-19th century, the *Māhele*, or division, converted the Hawaiian system of land from communal to private. What was once the Waikīkī *ahupua'a* became divided into many smaller parcels subject to title, ownership, and development. Although much of the land in Waikīkī became the personal property of Hawaiian *ali'i*, the cultivation of taro gave way to the cultivation of rice. After Hawai'i was annexed by the United States, Waikīkī transformed into a suburban community, and its reputation as a tourist destination began to grow. Then, beginning in 1922, the Waikīkī Reclamation Project primed Waikīkī for massive residential and hotel development. The project would foreground conflicts between community values, the preservation of open space, and agriculture on the one hand and the exploitation of newly available real estate for suburban and later urban resort development on the other. As is well known, urbanization triumphed, and the wetlands that provided habitat for native flora and fauna and that sustained the farms of native Hawaiians and Chinese immigrants were lost.

The boundaries of the original wetland area that Waikīkī comprised were over 2,000 acres. Today Waikīkī proper has been reduced to just over 600 acres. Of that 600, only about one-third can be considered semi-rural open space—the roughly 200 acres that make up the beaches, Fort DeRussy, and Kapi'olani Park.

Hawaiian royalty, European and American entrepreneurs, and Asian immigrants all played roles in the ultimate transformation of Waikīkī. This transformation enables Waikīkī to accommodate an estimated 72,000 tourists per day, totaling over 4 million per year. But the geographic limits placed on the community during this transformation create a roughly two-mile-long-by-three-block-wide area that as of the 2000 Census claimed fewer than 20,000 residents.

The images and stories in the first part of this book focus primarily on Waikīkī before mass tourism and the popularization of surfing, when Waikīkī was a place of rich agriculture and aquaculture. It was a place where indigenous birds nested and fish spawned, a place where Hawaiians and Chinese farmed together. Waikīkī was a place of community for the Japanese hotel workers and foreign and local entrepreneurs who raised families and started community businesses in the neighborhoods near the ocean, streams, and ponds. The second part of the book is about how a massive dredge and fill project in the early decades of the 20th century fundamentally transformed the ecosystem and the community. At the center of this project was the creation of the Ala Wai Canal. There were, of course, political and economic factors that led to this, but the concept of preservation of landscape and culture seem to have been eclipsed during this period by a compulsion to develop larger hotels and apartment buildings. Nonetheless, Waikīkī has remained a meeting place of fresh and salt water, of sand and sea, and of locals and foreigners. Ultimately, the purpose of a book such as this one is to help ensure that the past, both good and bad, remains a part of our collective memory.

One

FOREIGN DISEASES AND FOREIGN GODS

THE UNDOING OF TRADITIONAL HAWAIIAN CULTURE

Because of their isolation, little if any contact occurred between Hawaiians and Westerners prior to 1778, when the islands were visited by a group of British ships commanded by Capt. James Cook. Under the stewardship of Hawaiians prior to 1778, Waikīkī was a place of rich, sustainable agriculture, where Hawaiians raised taro, fished, worshipped their gods, and delighted in the excellent surf found there.

There was also occasional warfare, as ruling chiefs would sometimes clash for dominance. Because Waikīkī had for several centuries been the center of power on Oʻahu, it was here that invading armies from other islands would land, covering the shoreline with hundreds of canoes and thousands of warriors.

After 1778, foreign diseases ravaged the Hawaiian population. The reign of King Kamehameha I (1795–1819) was plagued by hundreds of thousands of Hawaiians dying from diseases against which they had no immunity. Because so many were dying, Hawaiians likely felt that their traditional gods had abandoned them. After Kamehameha's death, Queen Kaʻahumanu ordered the destruction of *heiau* (temples) and the disbandment of the priesthood that had been key to maintaining power.

In 1820, the first group of American missionaries arrived, and Kaʻahumanu, along with many other Hawaiians, soon converted to Christianity. Encouraged by the missionaries, Kaʻahumanu imposed laws against the consumption of rum and against prostitution.

In 1824, whooping cough and measles swept through the Hawaiian population, causing many deaths. In the same year, measles claimed the lives of King Liholiho and Queen Kamāmalu while they visited England, awaiting a meeting with King George. In the early 1840s, an epidemic of mumps killed thousands more Hawaiians, and in 1853, a smallpox epidemic also killed thousands. A small hospital was built in Waikīkī for the care of Hawaiians with smallpox.

It was in this context that the taro fields and fishponds of Waikīkī went untended. The fields and ponds were overrun with bulrushes. The sophisticated agricultural system that had sustained Hawaiians for centuries suffered along with the people who created it.

In 1848, a further and more profound undoing of Hawaiian culture resulted from a major change in the land-tenure system. The *Māhele* of 1848 opened the Hawaiian Islands to western land barons, who, by 1852, controlled thousands of prime acres throughout the kingdom. In the period immediately after the *Māhele*, though, most of the land of Waikīkī remained the property of Hawaiian royalty.

This 1859 photograph shows the Helumoa coconut grove. Planted during the reign of Kākuhihewa in the 16th century, it reportedly grew to over 10,000 palms. *Helumoa* literally means "chicken scratch" and refers to a visitation Kākuhihewa received from the phantom rooster of Pālolo. In the legend, he ordered a coconut planted at the spot where the rooster appeared before him. This area was a favorite home of Hawaiian *ali'i*, or royalty, because of its proximity to abundant food and water, as well as to good surfing. All of the Hawaiian monarchs who ruled through the 19th century had homes at or near Helumoa. Today the trusts created originally by Hawaiian royalty still own much of the land in Waikīkī. What is left of the grove can still be seen in the area between the Royal Hawaiian Hotel and the adjacent shopping center. Diamond Head, the other prominent feature in the photograph, was called Lēʻahi by Hawaiians and was the site of several important *heiau*, including Papaʻenaʻena, used by both Kamehameha I and Kahekili. Diamond Head also figured into native Hawaiian resistance to the overthrow in the counterrevolution of 1895. It is currently protected under its designation as Diamond Head State Monument and as a National Historic Landmark. A partnership between the Diamond Head Citizens Advisory Committee and the Department of Land and Natural Resources (DLNR) seeks to promote the protection of Diamond Head and its significant natural and cultural resources under the Diamond Head Master Plan, enacted into law in 1992 by the Hawaiʻi State Legislature. (Courtesy Hawaiʻi State Archives.)

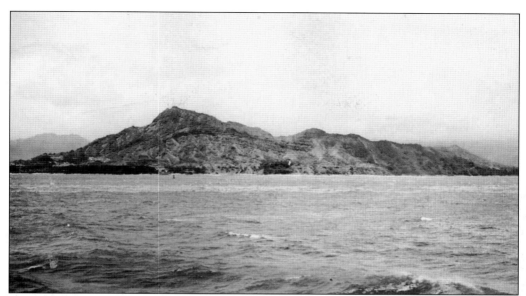

This view of Diamond Head from the east reveals something of its early geologic history. For visitors arriving by ship, boat, or perhaps by ancient Polynesian sailing canoe, it is a welcoming prelude to the first view of Waikīkī, only a few minutes away. (Courtesy U.S. Army Museum of Hawai'i.)

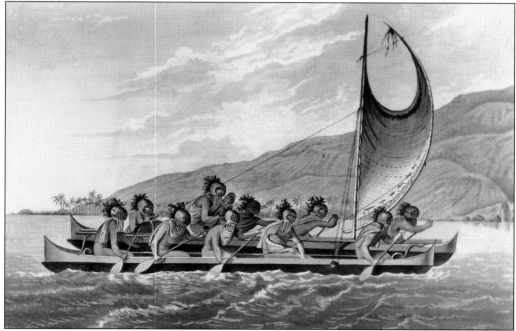

This enigmatic illustration is labeled "war canoe;" however, close examination suggests that the double-hulled canoe was on a religious mission. Passengers carry no weapons. Instead, the figure in the middle carries an idol of some sort; another figure carries what appears to be a case; and a third seems to be attending a dog or possibly a pig. (Courtesy Hawai'i State Archives.)

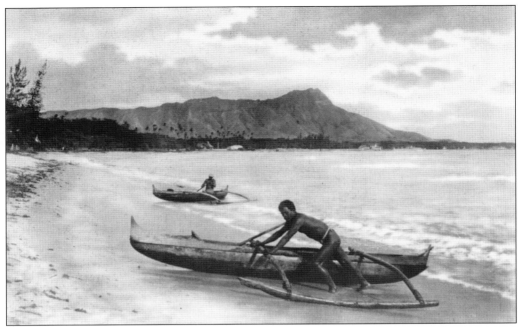

The *wa'a*, or outrigger canoe, once served as the primary means of transportation over water. Traditionally, each canoe was made from a single *koa* tree found in the mountains, where it would be rough-hewn then dragged to the shoreline for finishing. The man in the photograph wears a *malo*. (Courtesy Hawai'i State Archives.)

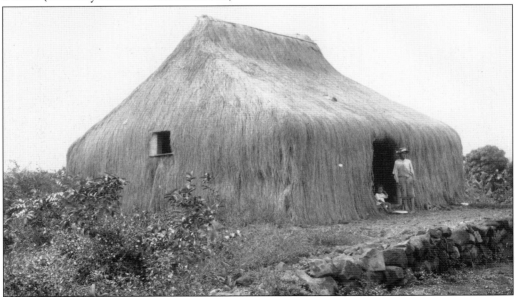

Until the 1800s, Waikīkīans lived in *hale pili* similar to the one here. *Pili* is a type of grass that was cultivated in large fields in drier areas of the island. The grass was thatched to the house frame and would last for up to 10 years. The steeply pitched roof of the traditional grass house became a common element in Hawaiian architecture. (Courtesy Bertram Collection, Hawai'i State Archives.)

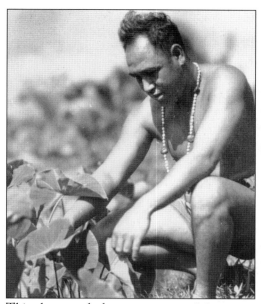

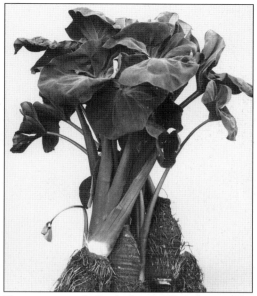

This photograph shows a man examining a taro field. Hawaiians held taro, or *kalo*, to be sacred because it was believed to be the living form of Hāloa, the first human. Conditions in Waikīkī were ideal for taro growing because of abundant water and sun. (Courtesy Hawaiian Collection, University of Hawai'i Hamilton Library.)

Taro was a staple food of early Waikīkīans. The taro root would be beaten into *poi*. Its young leaves would be cooked, as would its stems. Taro is cultivated from plantings of stems and is harvested after about 12 months. Early Hawaiians developed an intricate irrigation network to support large-scale taro cultivation in Waikīkī. (Courtesy Bertram Collection, Hawai'i State Archives.)

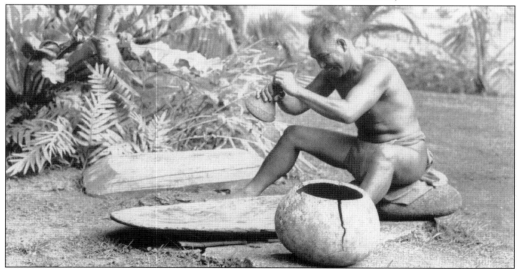

The making of *poi* from cooked taro corms was a labor-intensive process. After cooking the taro in an underground oven for about two hours, a man would use a stone *poi* pounder to mash it into a paste that could be easily stored and transported. It took about one hour of work to produce four pounds of *poi*. (Courtesy Hawaiian Collection, University of Hawai'i Hamilton Library.)

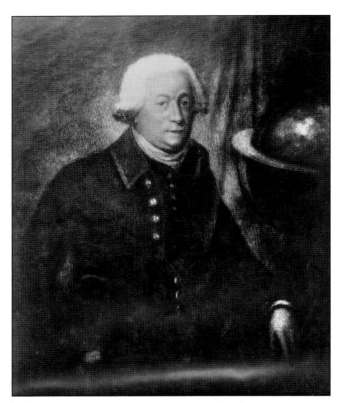

Capt. George Vancouver may not have been the first white man to visit Waikīkī, but he and one of his crew were the first to write about the area during their 1792 voyage. These impressions provide the first written account of the sophisticated agriculture and generous spirit of the Hawaiians there. (Courtesy Hawai'i State Archives.)

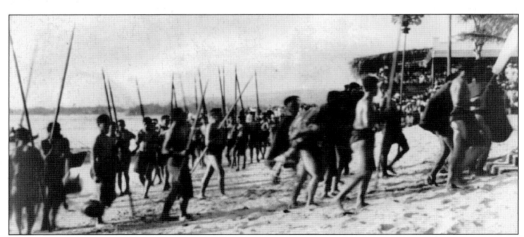

When Kamehameha landed on O'ahu early in 1795 with some 10,000 warriors and 1,200 double-hulled canoes, as well as a 36-foot ship with a small canon, he chose Waikīkī because it contained abundant food and water. This 1913 photograph depicts a reenactment of the landing. (Courtesy Library of Congress.)

After Kamehameha landed in Waikīkī, he vanquished the forces of Kalanikūpule, son of Kahekili, the Maui chief who had overrun Oʻahu 12 years before. Kamehameha lived in Waikīkī until 1809. During this time, he successfully unified all of the Hawaiian Islands, thus becoming the first *mōʻī*, or king, of the Hawaiian Nation. (Courtesy Hawaiʻi State Archives.)

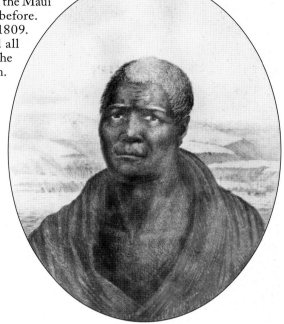

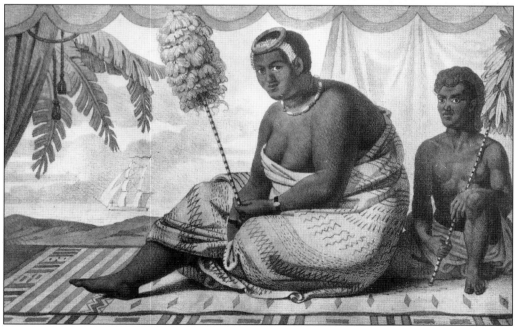

After the death of Kamehameha I, his wife Kaʻahumanu, above, asserted immense influence and functioned as *kuhina nui*, or regent, from 1824 to 1832. In the wake of massive deaths of native Hawaiians due to Western diseases, Kaʻahumanu broke the *kapu* system, which was the center of traditional Hawaiian religion, by eating with male members of her family. (Courtesy Hawaiʻi State Archives.)

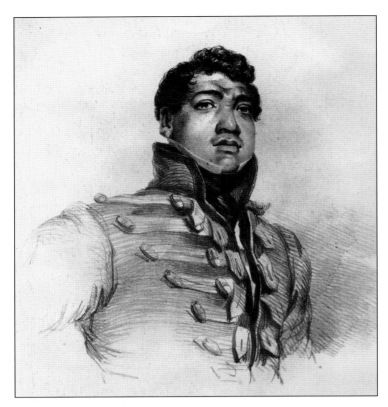

Several months after Kamehameha's death in 1819, his son Liholiho, Kamehameha II, with strong support from Kaʻahumanu, ended the traditional Hawaiian religion. Temples were burned, images of the gods were destroyed, and *kahuna*, or priests, were dismissed. The following year, the first Calvinist missionaries arrived from the United States. (Courtesy Hawaiʻi State Archives.)

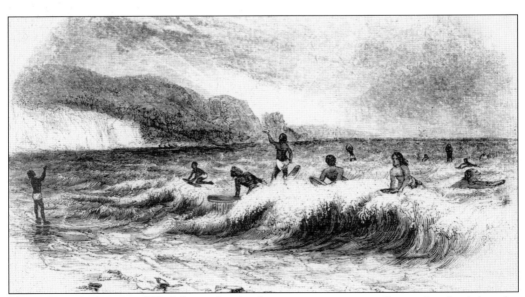

Throughout the history of Waikīkī, surfing has been a primary means of recreation, but it has also been an activity through which "play" has been extended to spiritual celebration and regeneration. Unfortunately Calvinist missionaries discouraged surfing during the period of their influence in the 19th century. (Courtesy Hawaiʻi State Archives.)

16

This 1824 portrait of Chief Boki and his wife Liliha was made by John Hayter in London. Boki and Liliha had traveled to London with King Liholiho and Queen Kamāmalu in order to request of King George IV that Great Britain protect Hawai'i against foreign invasion. Tragically both Liholiho and Kamāmalu died in London of measles. Subsequently, Boki met with King George, and the request was granted. (Courtesy Hawai'i State Archives.)

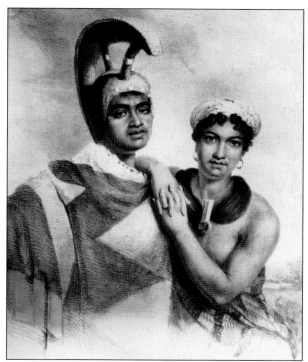

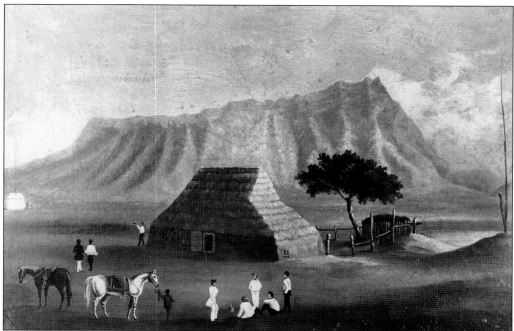

This small grass house served as a smallpox hospital during the epidemic of 1853 and 1854. Over 3,000 Hawaiians died during the outbreak. From ancient times, Waikīkī was known as a sacred place with extraordinary regenerative and healing power. The original color painting of the smallpox hospital is at Honolulu's Mission House Museum. (Courtesy Hawai'i State Archives.)

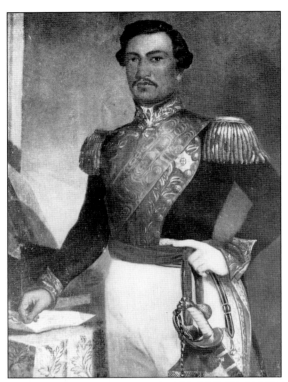

Kauikeouli, King Kamehameha III, succeeded his brother Liholiho when he was but 10 years old. Political power, however, remained with Ka'ahumanu until her death in 1832. Under great pressure from foreigners, Kauikeouli agreed to the land reform known as the 1848 *Māhele*, which allowed private ownership of land. Kauikeouli himself received ownership of 62 acres in Waikīkī. (Courtesy Hawai'i State Archives.)

Gerritt Judd (left) sits in 1849 with Prince Alexander Liholiho (center), later Kamehameha IV, and his brother, Prince Lot Kamehameha, later Kamehameha V. Judd, an influential missionary, was instrumental in bringing about the *Māhele* of 1848. In order to encourage the cultivation of taro, Liholiho maintained a 17-acre taro field in Waikīkī. He was succeeded by Lot, who in 1866 built a cottage at Helumoa. (Courtesy Hawai'i State Archives.)

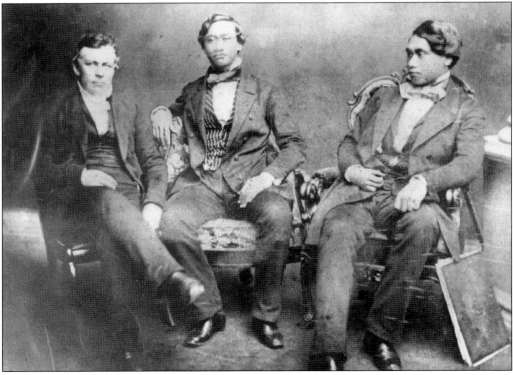

Two

Designs on the Land
From Monarchy to Republic

The decades following the *Māhele* of 1848 were a time of turmoil for the kingdom and for Waikīkī. Changes in land ownership shifted the economic and political power structure. Sugar became the center of the Hawaiian economy. Large sugar plantations depended on contract laborers who came from Asia and who brought major changes to Waikīkī's wetland agriculture. The cultivation of rice and the raising of ducks and fish came under the management of mostly Chinese entrepreneurs. In the 1860s, the widening of Waikīkī Road improved access to Waikīkī, but it also severely interfered with drainage. Concerns about sanitation arose, and conflict emerged between the wetland farmers and those desiring to build homes, especially along the beach.

The succession of Kamehameha monarchs ended with the election of King David Kalākaua in 1874. Kalākaua was responsible for changes in relations with the United States, including the Reciprocity Treaty that allowed Hawaiian sugar and other products to enter the United States duty free. In 1887, the amended treaty gave the United States use of Pearl Harbor as a naval base. In 1876, the Kapiʻolani Park Association was formed, followed by the creation of a carefully landscaped park and horse-racing track surrounded by residential lots just below Diamond Head. King Kalākaua provided 300 acres of crown land for the project. The shareholders of the association aimed to create an exclusive suburban retreat.

Throughout the 19th century in Hawaiʻi, the presence of foreign, mostly American, businessmen like Benjamin Franklin Dillingham and Claus Spreckels led to the increasing influence of Americans in matters related to finance and politics. In 1865, Dillingham arrived in Hawaiʻi as the first mate on a merchant ship and within two decades had built a railroad that bolstered the emerging plantation economy. Spreckels was a San Francisco businessman who became one of the sugar barons; he would have immense influence over Kalākaua and the Hawaiian economy. Other new settlers, like former African American slave Anthony Allen and Chinese immigrant Chun Afong, also found success and were influential in business and politics.

By the late 1880s, Kalākaua's power was increasingly challenged by American business interests. After his death in 1891 and the succession of Queen Liliʻuokalani, relations between the monarchy and American commercial interests further deteriorated. With the aid of a U.S. Navy ship, the queen was overthrown and kept under house arrest at ʻIolani Palace. A new government, calling itself the Republic of Hawaiʻi, was created, with wealthy businessman Sanford Dole as president.

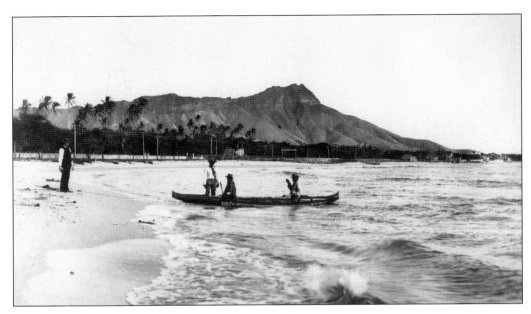

There are likely no more iconic or enduring images of Waikīkī than those that include the basic elements shown here: the outrigger canoe, paddler, passenger, Diamond Head, the sand, and perhaps a wave. While much has been made of this sort of image in marketing Waikīkī to tourists, it is the utilitarian function of the canoe, not the recreational one, that comes forth in these two photographs. In the photograph above, *c.* 1900, the man on the shore is perhaps waiting to be picked up. In the photograph below, also *c.* 1900, the canoe has been pulled out of the water, and a fishing net hangs from the tree in the background. (Courtesy Hawai'i State Archives.)

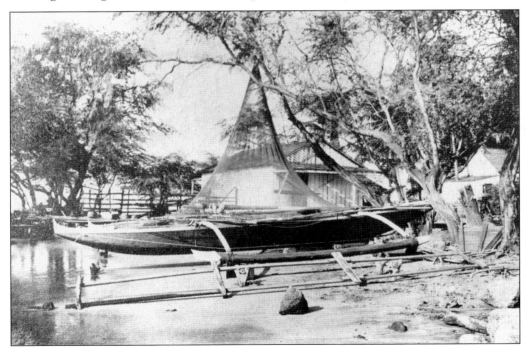

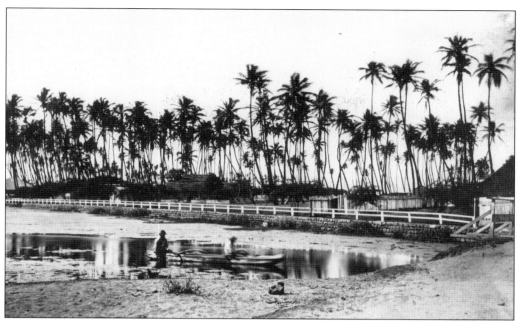

On the left of this photograph is the grass house owned by Kamehameha V. Taken in the early 1880s from Waikīkī Road, it also shows the ʻĀpuakēhau Stream. This area, known as Helumoa, has profound significance because it has been the location of homes occupied by important *aliʻi* going back many generations. (Courtesy Hawaiʻi State Archives.)

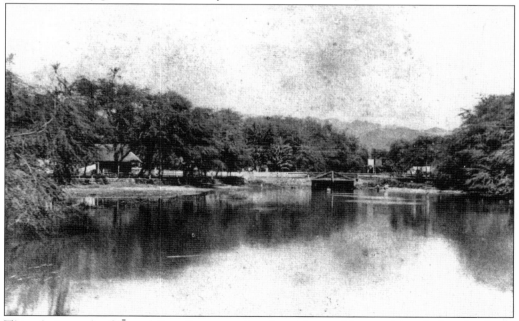

This photograph of ʻĀpuakēhau Stream, taken from the sand berm along the beach, shows Waikīkī Road crossing the stream. In Hawaiian, the word *ʻāpua* means fish trap, and *kēhau* means either dew or light offshore breeze. This area of Waikīkī was also once the site of an important Hawaiian *heiau* that dated from at least the 14th century. (Courtesy Hawaiʻi State Archives.)

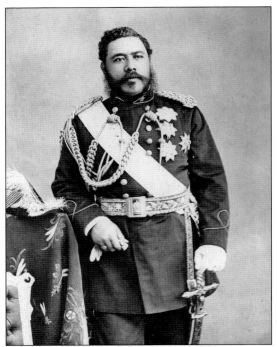

David Kalākaua was king of Hawai'i from 1874 until his death in 1891. He actively supported the sugar industry and encouraged traditional Hawaiian cultural practices like the *hula*. He was also a key figure in the creation of the Kapi'olani Park Association, originally a real estate venture that has since resulted in the long-term preservation of the park. (Courtesy Library of Congress.)

The Hawaiian words on the coat of arms used by the Kingdom of Hawai'i also appear on the seal of the State of Hawai'i. *Ua mau ka ea o ka 'aina i ka pono* translates as "The life of the land is perpetuated in righteousness." An abbreviated form of this sensibility is found in the common Hawaiian phrase *aloha 'aina*, which means love of the land. (Courtesy Hawai'i State Archives.)

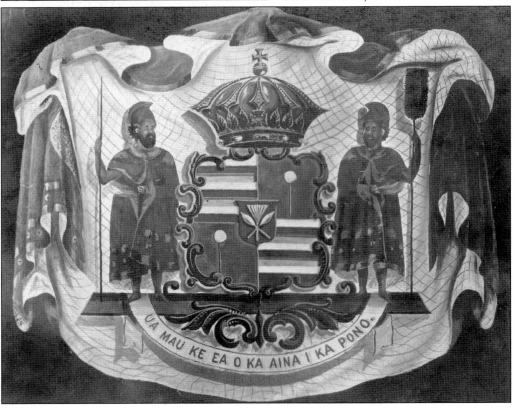

The $1 silver coin known as the *'Akahi Dala* is considered a numismatic treasure, as are other coins minted by the Kingdom of Hawai'i. With the strong encouragement of sugar baron Claus Spreckels, Kalākaua decided to have them produced at the San Francisco mint. In order to save production costs, the coins were produced in three denominations, all matching U.S. coins already in production. (Courtesy Hawai'i State Archives.)

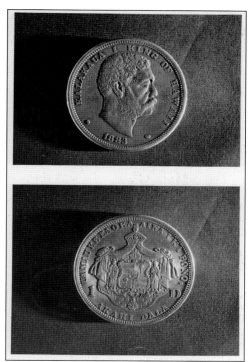

Claus Spreckels (second from left) represents the penultimate *malihini*, a common Hawaiian word for newcomer. A millionaire from San Francisco, he arrived in Hawai'i in 1876. He was able to assert immense control over the Hawai'i sugar market because of his monopoly on West Coast sugar refining. In the 1880s, his Oceanic Steamship Company controlled most shipping between San Francisco and Hawai'i. (Courtesy Hawai'i State Archives.)

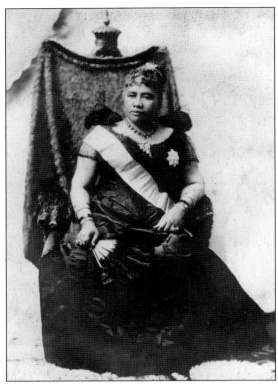

Lili'oukalani became queen in 1891 after the death of Kalākaua. In 1893, she was overthrown by a group of businessmen who established the Republic of Hawai'i while they sought the annexation of Hawai'i to the United States. She owned a home in Waikīkī near Kapi'olani Park; the land she owned is today owned and managed by the Lili'oukalini Trust, one of the largest landowners in Hawai'i. (Courtesy Hawai'i State Archives.)

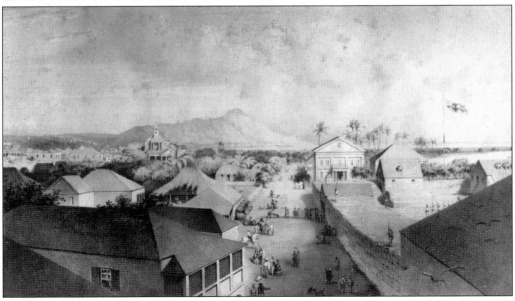

This lithograph depicts Honolulu in the 1860s. The road to Waikīkī in the center of the photograph and the view of Diamond Head suggest a relationship between the town and the country. With the widening of Waikīkī Road (later Kalākaua Avenue) in 1860, Waikīkī, still not quite a suburb, became a desirable after-work or weekend destination for the growing population in Honolulu. (Courtesy Hawai'i State Archives.)

Benjamin Franklin Dillingham came to Hawai'i in 1865. He promoted the expansion of sugar plantations on O'ahu by connecting them with a railroad that he commissioned and built with the help of financiers James B. Castle and Mark P. Robinson. The Dillingham empire would become an integral part of Waikīkī's transformation when his eldest son, Walter Francis Dillingham, founded the Hawaiian Dredging Company. In 1920, Hawaiian Dredging was awarded the contract for the construction of the Ala Wai Canal. (Courtesy Hawai'i State Archives.)

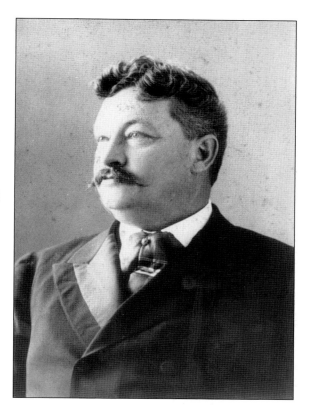

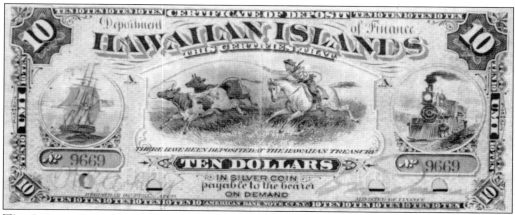

This $10 note, issued in 1880, was printed in New York by the American Bank Note Company. Representations of shipping, ranching, and railroading say much about the commercial aspirations of the time. Shipping and railroading were instrumental to the rapidly expanding sugar industry, which allowed wealthy industrialists to build large homes in Waikīkī. (Courtesy Hawai'i State Archives.)

Sanford B. Dole, shown here on his 80th birthday, became president of the provisional government in Hawai'i following the 1893 overthrow of the queen. Under the Republic of Hawai'i, Dole and the 1896 legislature passed Act 61, authorizing the Board of Health to determine if land was unsanitary and to recommend improvements. Act 61 became law after annexation and provided the platform for the Waikīkī Reclamation Project. (Courtesy Hawai'i State Archives.)

When King Kalākaua signed the "Bayonet Constitution" of 1887, the power of the Hawaiian monarch was greatly reduced. The new constitution also imposed voting regulations that required higher income and property qualifications of voters and candidates for office. Kalākaua died in January 1891, and it is often argued that his signing of the Bayonet Constitution helped lead Hawai'i to annexation. (Courtesy Hawai'i State Archives.)

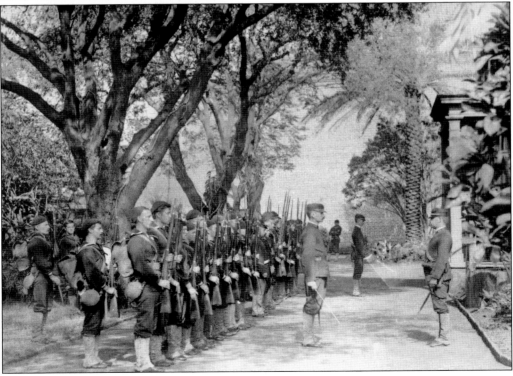

Chun Afong, who arrived in 1849, became the first Chinese millionaire in Waikīkī. Afong made his fortune in such varied trades as retail, real estate, sugar, rice, and opium. After marrying Julia Fayerweather, of royal Hawaiian lineage, Afong became a member of King Kalākaua's privy council. Afong's three-acre Waikīkī villa was the venue of many grand parties. (Courtesy Hawai'i State Archives.)

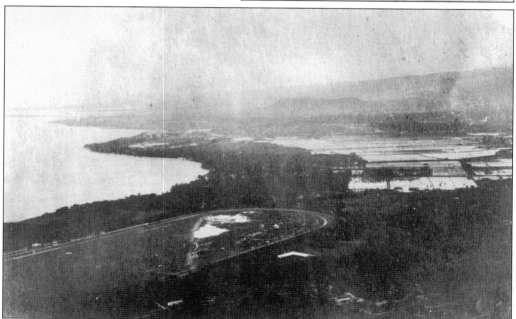

Because no large homes or hotels can be seen along the coast, this photograph was probably taken in the late 1880s. Flooded rice fields dominate the right side, and fishponds can be seen on the left. The contrast of the rice fields and ponds with the Kapi'olani Park racetrack foreshadows the conflict between recreation and sustainable agriculture. (Courtesy Hawai'i State Archives.)

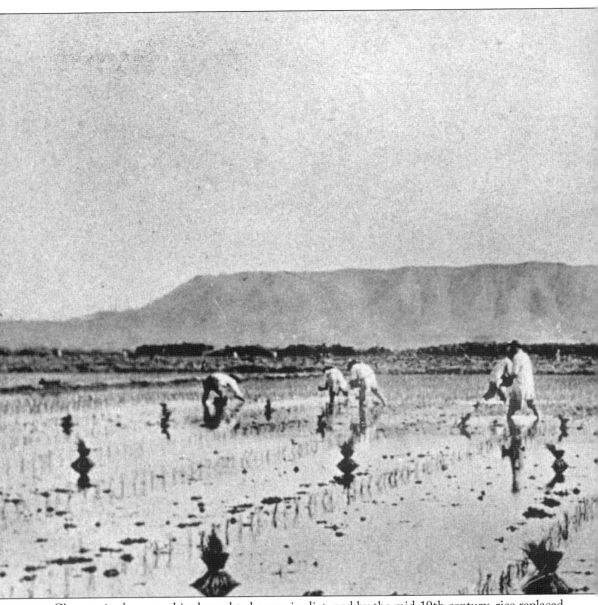

Changes in demographics brought changes in diet, and by the mid-19th century, rice replaced taro as one of the leading crops cultivated in Hawai'i. Chinese immigrants leased land from Hawaiians and converted taro fields into rice fields, which thrived in the same fresh running water as taro had. By 1892, Waikīkī had over 500 acres planted in rice and was the third largest rice producing area in Hawai'i. Throughout the period following the Reciprocity Treaty, rice

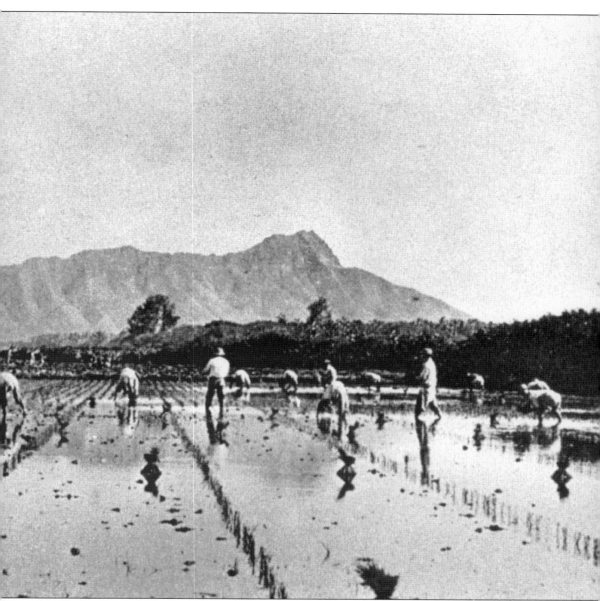

production increased rapidly. In 1882, exports peaked at over 13 million pounds. As the Asian population of Hawai'i increased, more rice was consumed locally. By 1899, rice exports amounted to just under one million pounds, while overall rice production continued to increase. (Courtesy Hawai'i State Archives.)

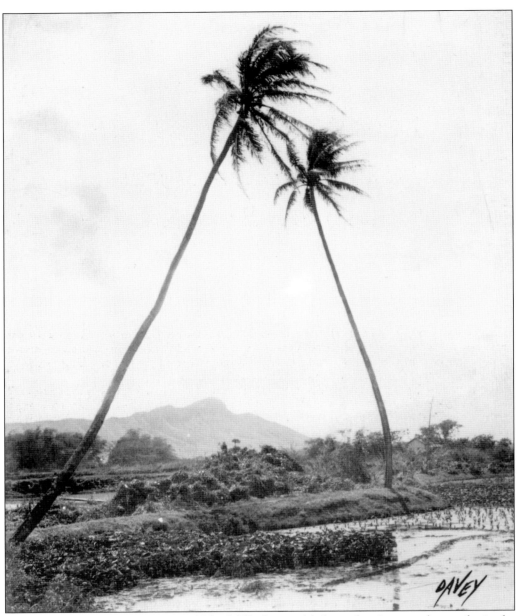

Two coconut palms frame Diamond Head. The haze is likely a volcanic smog that settles in the skies when southeasterly winds blow Kilauea's "vog" up from Hawai'i island. *Niu*, or coconut trees, were introduced to Hawai'i by early Polynesian settlers. While the coconut itself was used for food, the fiber of the husk was braided or twisted into cordage that was used for lashings in canoe construction. *Niu* was associated with the god Kū. Although the photographer has foregrounded the rice and taro patches, the framing of a shadowy Diamond Head communicates a relationship to the preeminent landmark of Waikīkī. This hazy view portends a clouding not only of the skies but of the future of agriculture in Waikīkī. As freshwater ponds became contaminated with murky salt water from Ala Wai dredging, the centuries-old system of Hawaiian wetland agriculture was destroyed. (Courtesy Hawai'i State Archives.)

Three

Tourism Begins

Day-Use Bathhouses
and Sea Bathing

In the late 19th century, Waikīkī's shoreline was mostly a day-use beach; overnight accommodations were scarce. Visitors were usually residents of Honolulu who would arrive via horse-drawn carriage, on horseback, or in a canoe. They came to enjoy gazing at the surf or taking a sea bath and had little expectation beyond these modest motives.

As "sea bathing" gained popularity in coastal areas of the United States, as well as in England, private bathhouses began to appear in Waikīkī. The first organized efforts to attract foreign visitors included the publication in 1875 of the *Hawaiian Guidebook for Tourists* and in 1890 of *The Tourists' Guide through the Hawaiian Islands.*

Bathhouses like the Long Branch Baths, the Ilaniwai Baths, and Wright's Villa served customers with bathing suits and towel rentals, dressing rooms, and easy access to the beach. Initially the bathhouses served only the day-use recreation of visitors, but eventually some of them began to offer overnight rooms.

Demand for overnight accommodations remained small in 19th-century Waikīkī. When the Park Beach Hotel opened in 1888, it offered only 10 rooms. The hotel lasted less than a year, and in 1889, it was purchased and used as a residence by James B. Castle. Another brief, but famous, chapter in Waikīkī's early hotel industry was the Sans Souci. The Sans Souci Hotel, which enjoys the enduring status of having had Robert Louis Stevenson as a guest, later became the meeting place of royalists sympathetic to the monarchy. But the tourist industry would not yet support the overnight hotel, and the Sans Souci soon closed.

Waikīkī was considerably less than first class in its accommodations before the beginning of the 20th century. In 1894, a visitor wrote, "with the exception of a few unpretentious cottages, there is not the remotest sign of its being a watering-place. A wooden shed, in which one can undress, is called, so the guide-book assures me, 'The Long Branch Baths.' " Such a negative travel review foreshadowed nothing of the future fate of Waikīkī as one of the most-visited beachfront resorts in the world.

'AIKIKI AND DIAMOND H'D - S. BERTRAM -

Brother Bertram likely took this photograph from atop the famous toboggan slide located between the Long Branch Baths and the ʻĀpuakēhau Stream. Established in 1881 by James Dodd, the Long Branch (bottom right) was likely the first bathhouse in Waikīkī. By 1889, the establishment offered 42 changing rooms for men and 18 for ladies. From downtown Honolulu, where the harbor and hotels were located, visitors could take a mule-drawn carriage to Waikīkī and be admitted to the baths, all for only 50¢. The photograph shows a placid and virtually unspoiled Waikīkī with Diamond Head in the background. Brother Bertram Gabriel Bellinghausen, a member of the Catholic Marianist Order, arrived in Honolulu from Dayton, Ohio, in 1883 to teach at Saint Louis College. He remained in Hawaiʻi until 1905. During his residence in Hawaiʻi, he traveled throughout the islands, taking photographs wherever he went. (Courtesy Bertram Collection, Hawaiʻi State Archives.)

Waikīkī Road, shown here about 1898, became Kalākaua Avenue in 1905 by an act of the Territorial Legislature. The original building of the road in the 1860s had the effect of blocking the natural flow of waters from the mountains into the large shoreline estuary. The photograph was taken by Prof. Carl Andrews. (Courtesy Hawai'i State Archives.)

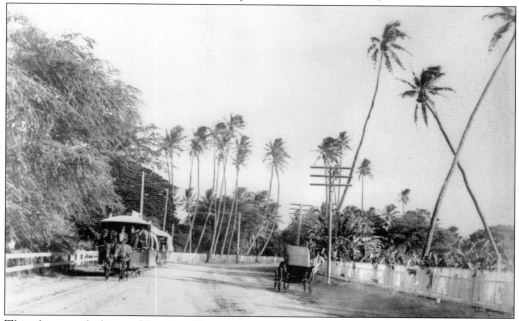

This photograph shows a Hawaiian Tramways streetcar carrying passengers along Waikīkī Road. In 1884, King Kalākaua commissioned an English firm, Skinner and Company, to lay tracks in Honolulu and Waikīkī. By 1888, the tramcars, pulled by teams of mules or horses, provided transportation over 12 miles of track. The cost of rides varied from a nickel to 15¢. Tramcars were replaced by electric trolleys in 1903. (Courtesy Hawai'i State Archives.)

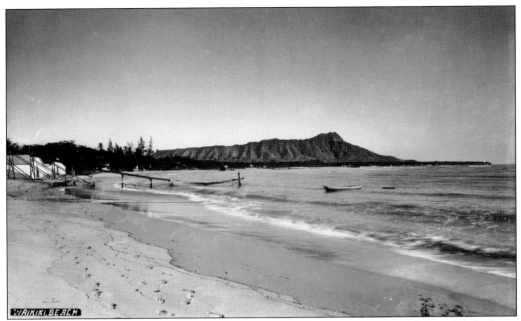

This photograph shows a portion of the famous Long Branch toboggan slide, modeled after a similar structure in Connecticut. Some 40 feet tall, it was an amusement structure down which people would slide and then skim across the water, sometimes for over 100 yards. (Courtesy Bertram Collection, Hawai'i State Archives.)

Waikīkī Road (later Kalākaua Avenue) can be seen here after it was widened in the 1860s. The improvements allowed mule-drawn wooden carriages to bring visitors to Waikīkī from Honolulu. Hawaiian Tramways streetcars replaced the carriages by 1888. The streetcar tracks are visible on the right. (Courtesy Hawai'i State Archives.)

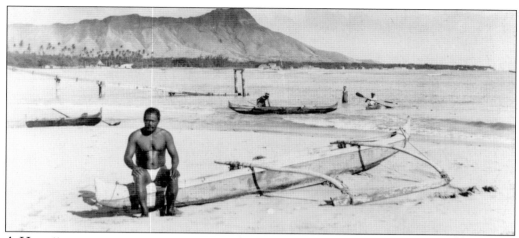

A Hawaiian man poses on a canoe near the Long Branch Baths around 1890. ʻĀpuakēhau Stream enters the ocean directly behind him. A second man prepares to launch a canoe while a third looks on, and a fourth paddles a surfboard with a two-bladed kayak paddle. The end of the toboggan slide is visible in the background. (Courtesy Hawaiʻi State Archives.)

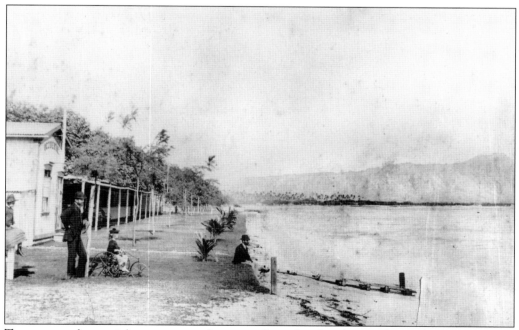

Two men and two girls gaze out at the ocean from the shoreline in front of the Occidental, *c.* 1880. The Occidental was one of several bathhouse businesses that provided small cabanas used as changing rooms. The ramp was used for moving canoes in and out of the water. (Courtesy Hawaiʻi State Archives.)

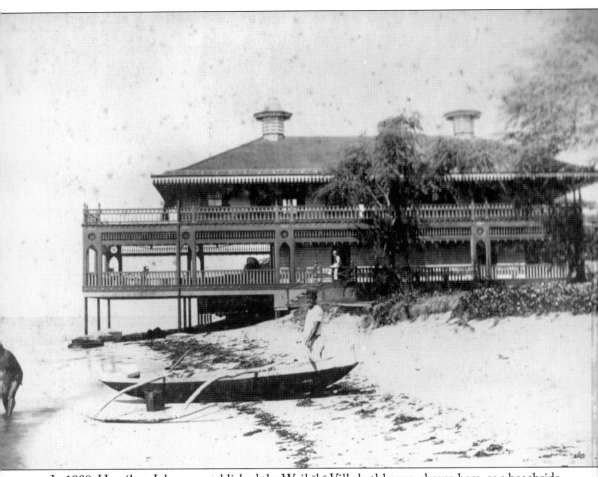

In 1889, Hamilton Johnson established the Waikīkī Villa bathhouse, shown here, as a beachside annex for guests of his Honolulu hotel, Hamilton House. After Johnson acquired the prestigious Hawaiian Hotel, the bathhouse became known as the Hawaiian Annex. An extensive wraparound lanai was built, with pillars supported by reinforced concrete feet that enabled the oceanfront pavilion to be extended out over the water. By 1885, at the time of this photograph, the Annex offered four rooms for overnight guests. The Hawaiian fishermen and their canoe in the foreground contrast sharply with the large building and the Victorian dress of the man resting on the Annex balcony. This contrast of activities and of dress are on the surface of a much deeper conflict growing in Waikīkī in the 19th century between traditional Hawaiian values and commercial tourism. The Sheraton Waikīkī now occupies the area where Hawaiian Annex used to stand. (Courtesy Hawai'i State Archives.)

In 1893, just as Queen Lili'oukalani's government was being overthrown by annexationist businessmen, George Lycurgus leased the Sans Souci Hotel (below) at Kapua near Kapi'olani Park from Allen Herbert. Lycurgus was a supporter of Lili'oukalani, and the Sans Souci became a focal point for the 1895 counterrevolution. Lycurgus and a number of others, along with Lili'oukalani herself, were arrested and charged with treason against the provisional Republic of Hawai'i government. The charges were later dropped. Afterwards, business at the hotel declined, and Lycurgus moved on to run the Volcano House on the island of Hawai'i. (Both courtesy Hawai'i State Archives.)

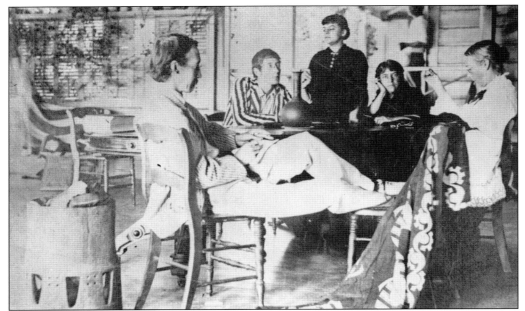

In 1889, and again in 1893, Robert Louis Stevenson visited Waikīkī, spending considerable time with King Kalākaua, Queen Liliʻoukalani, and Princess Kaʻiulani. Stevenson is shown here with friends at the Sans Souci Hotel. He wrote these lines for Kaʻiulani upon her departure for boarding school in England: "Forth from her land to mine she goes / the island maid, the island rose." (Courtesy Library of Congress.)

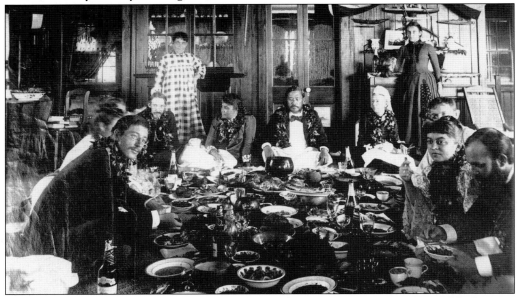

On February 9, 1889, Robert Louis Stevenson (rear left) and his family were entertained by Princess Liliʻuokalani (center) and King Kalākaua (far right) at this *lūʻau* hosted by Henry Poor at his Waikīkī house near the Sans Souci Hotel. Near the end of the evening, Stevenson presented the king with a pearl, along with a sonnet he had composed for the occasion. Stevenson was a strong supporter of the restoration of the Hawaiian monarchy. (Courtesy Hawaiʻi State Archives.)

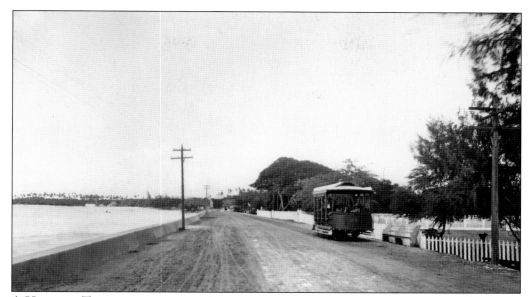

A Hawaiian Tramways streetcar with two passengers waits on the recently widened Kalākaua Avenue next to Kapiʻolani Park, around the late 1880s. Note the new seawall. Improved access to the park encouraged attendance at horse races. In the distance along the shoreline is the Long Branch Baths. (Courtesy Bertram Collection, Hawaiʻi State Archives.)

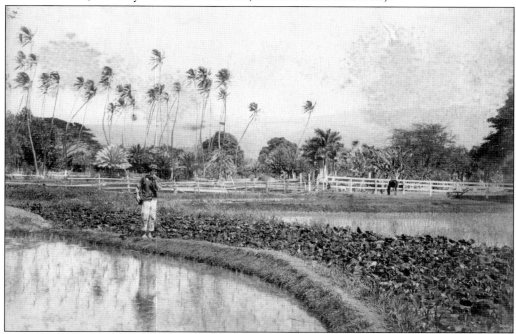

A worker stands between a field of taro and another of rice. Where taro had been the staple food for Hawaiians, rice was the staple for the rapidly expanding Asian population in Hawaiʻi. Because both sugar and rice production were growing rapidly, a shortage of agricultural workers emerged within a year after ratification of the 1876 Reciprocity Treaty. (Courtesy Hawaiʻi State Archives.)

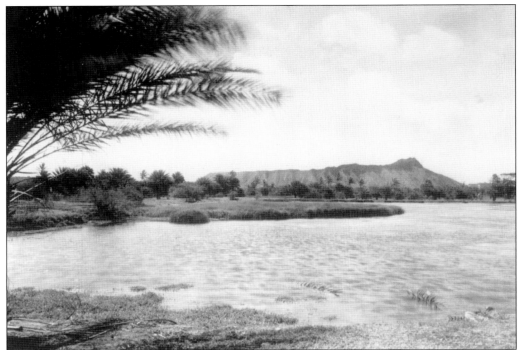

In 1915, Clinton G. Ballentyne wrote in *The Mid-Pacific*, "across the great rice fields and duck ponds . . . here you see . . . these industrious Chinese raise the thousands of mullet that are sold in the daily market." A few years later, if farmers would not fill their ponds, the government would put a lien against their property. (Courtesy Hawai'i State Archives.)

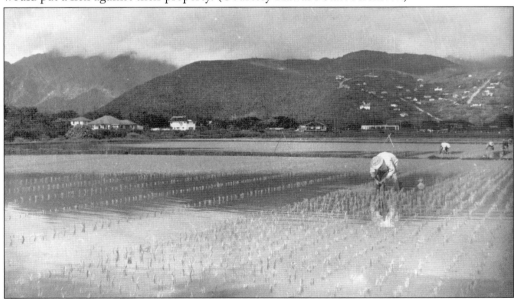

These workers are planting a rice field in upper Waikīkī in the 1920s. Waikīkī was the third largest rice-producing area in Hawai'i. Much of the rice produced in Waikīkī and elsewhere in Hawai'i was consumed locally by the growing Asian population. (Courtesy Hawai'i State Archives.)

Four

PRESERVATION OR
URBANIZATION
PRIVATE OR PUBLIC LAND?

As foreign desires on Waikīkī's land grew, so did demands on open space. While Kapi'olani Park has been preserved through the efforts of the Kapi'olani Park Preservation Society, as well as its original charter under Kalākaua, other areas in Waikīkī did not fare so well. In the commercial frenzy that followed annexation, 'Āinahau, Helumoa, and the entire 'Āpuakēhau and Pi'inaio estuary, all of which were once open and beautiful spaces, were lost to development.

Archibald Cleghorn, a Scottish immigrant and wealthy merchant, was also a talented landscape architect who landscaped the lavish 11-acre 'Āinahau estate. Cleghorn was the father of Princess Victoria Ka'iulani, who had inherited much of the land. Now the area around the intersections of Cleghorn, Tusitala, and Ka'iulani Avenues, the estate was located along the 'Āpuakēhau Stream and featured a two-story Victorian-style house, gardens, coconut palms, ponds, bridges, and walkways. Cleghorn died in 1910, and 'Āinahau was bequeathed to the Territory of Hawai'i under the condition that it become a public park dedicated to Princess Kai'ulani. Unfortunately the gift was refused by both the 1911 and 1913 legislatures, largely because one of the representatives was Archibald S. Robertson, a Cleghorn heir who inherited the estate upon its rejection as a park. Details of the beautiful estate are preserved in the photographs of Brother Bertram. Images such as these are all that is left of 'Āinahau, a place that could have become a public park in the heart of Waikīkī.

A much larger estate passed down through the Kamehameha line ended up with Charles and Bernice Pauahi Bishop. The original site of Helumoa and the various King Kamehameha summer homes, this area was also the site of one of the most important *heiau* in Waikīkī's history. The Helumoa coconut grove became the site of the Royal Hawaiian Hotel and an adjacent shopping center. The Bishop landholdings in the Kālia area were sold to Walter F. Dillingham and developed.

In other areas of Waikīkī, organizations like the Kapi'olani Park Preservation Society and Outdoor Circle were influential in helping guide zoning regulations that restricted development. Also, under some administrations, the governments of the city and county of Honolulu have been effective in guiding planning and preservation along the shoreline.

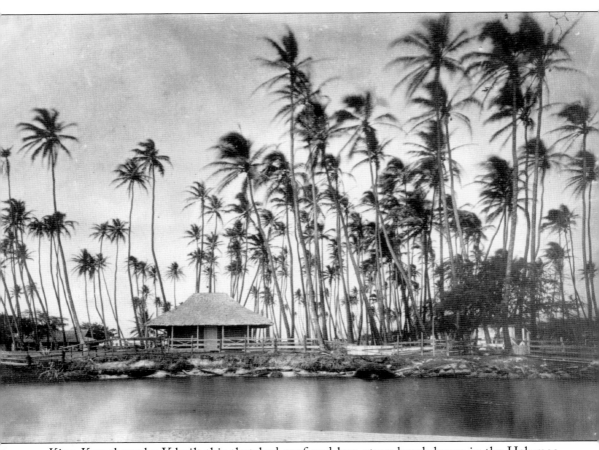

King Kamehameha V built this thatched-roof-and-lava-stone beach house in the Helumoa coconut grove in 1866. The modest residence contained only one bedroom and employed many elements of distinctly Hawaiian architecture found in the larger, more permanent dwellings that followed it. These elements included a high-pitched, hipped roof that allowed warm air to rise and kept the living area cool. The property passed to his half-sister, Princess Ruth Keʻelikōlani, upon his death in 1872. She in turn bequeathed it to her cousin, Bernice Pauahi Bishop. The Bishops expanded the home and added servants' quarters but kept many of the traditional elements of design employed by Kamehameha. The Helumoa area, coveted by *aliʻi* for its trees, freshwater, and salt water, was also the former home of Kahekili, Kahahana, Kamehameha I, and Kamehameha III. In 1906, it became the site of the Seaside Hotel. The Royal Hawaiian Hotel currently occupies this site. (Courtesy Hawaiʻi State Archives.)

Two women and a man enjoy a pond from a bridge in the wetland gardens of 'Āinahau about 1900. 'Āinahau was the residence of Princess Ka'iulani, who was heir to the Hawaiian throne. The landscaped waterways of 'Āinahau were drained during the Waikīkī Reclamation Project. (Courtesy Hawai'i State Archives.)

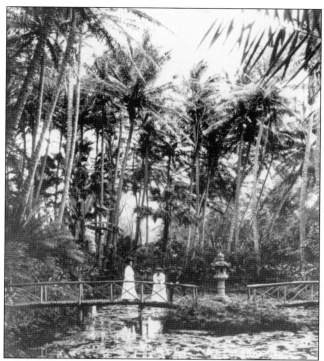

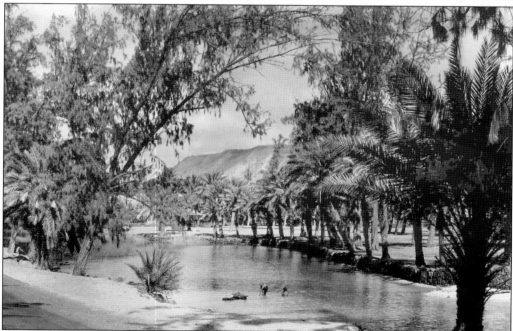

Two children enjoy some water play in Kapi'olani Park. The date palms and ironwood trees are the addition of Archibald Cleghorn and can be seen in many areas of the park today. Diamond Head can be seen in the background. The Honolulu Zoo would later be built near this site. (Courtesy U.S. Army Museum of Hawai'i.)

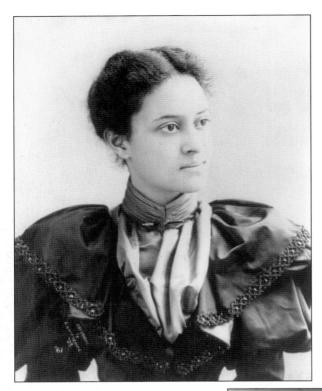

The daughter of Scotsman Archibald Cleghorn and Princess Miriam Likelike, whose brother was King Kalākaua, Princess Ka'iulani was heir to the throne, but the overthrow of the monarchy in 1893 and the U.S. annexation of Hawai'i in 1898 intervened. In 1899, Ka'iulani died at the age of 24. She was an excellent surfer and was well acquainted with poet Robert Louis Stevenson. (Courtesy Library of Congress.)

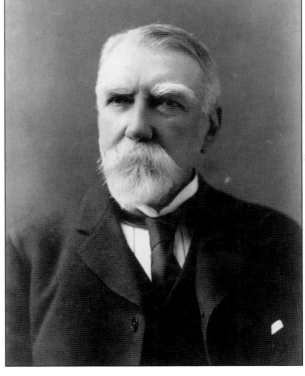

In 1870, Archibald Cleghorn, shown here, married Princess Miriam Likelike, the sister of Kalākaua. When Kalākaua became king, he appointed Cleghorn to the House of Nobles. Under Queen Lili'oukalani, he served for a time as governor of O'ahu. In 1896, after the overthrow of Lili'oukalani, he became president of the Honolulu Park Commission. (Courtesy Hawai'i State Archives.)

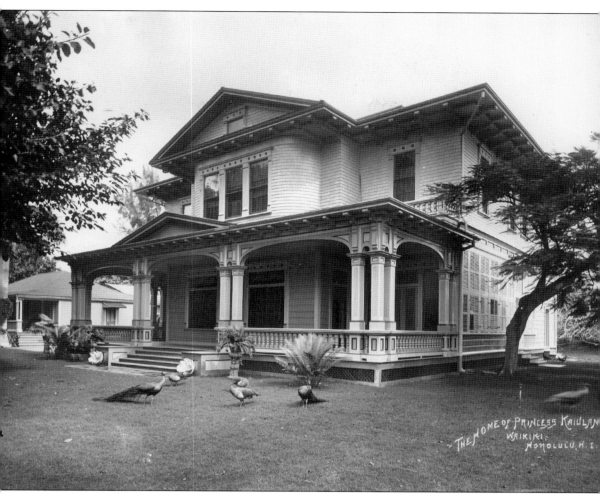

This Victorian house was built on the 'Āinahau estate in 1890 by Archibald Cleghorn and served as his family's residence. The two-story house was featured a facade-width lanai. It also contained an element found peculiar by many Hawaiians—screened windows. Although Waikīkī was notorious for mosquitoes in the years prior to the wetland reclamation, screens were not commonly used. The grounds of 'Āinahau were graced by another unusual feature—peacocks (visible in the foreground.) The exotic birds were pets of Cleghorn's daughter, Princess Ka'iulani. She could often be seen feeding the peacocks, which were allowed to roam freely. Unfortunately the house was destroyed by fire in 1921, and the grounds met their fate at the arm of the dredge during the Waikīkī Reclamation Project. (Courtesy Bertram Collection, Hawai'i State Archives.)

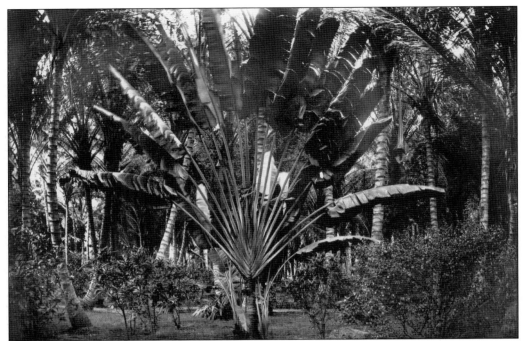

This travelers palm was part of the ʻĀinahau estate. The plant is not technically a palm, rather it is part of the banana family. It is so called because its large leaves hold enough water to be counted on for use in an emergency. (Courtesy Bertram Collection, Hawaiʻi State Archives.)

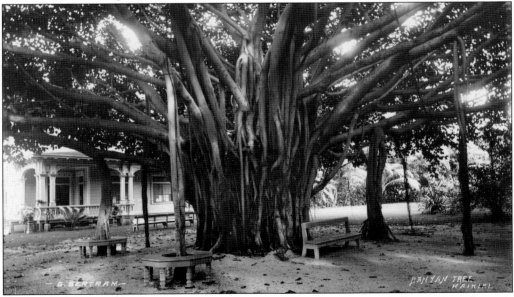

A central feature of the ʻĀinahau estate, this banyan tree and the area below its branches was preserved even after real estate developers had consumed the rest of the estate in 1917. Although Archibald Cleghorn willed the entire estate to the Territory of Hawaiʻi for use as a park, the government, influenced by real estate interests, refused to accept it. (Courtesy Bertram Collection, Hawaiʻi State Archives.)

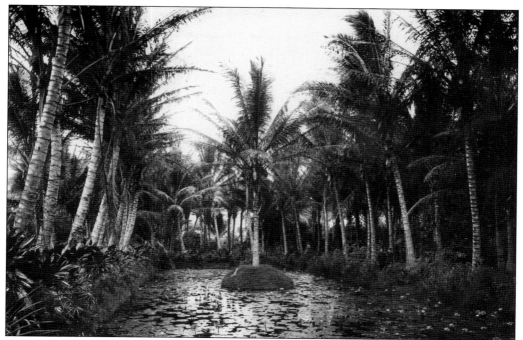

This is one of the ponds at ʻĀinahau. There was cause for some concern surrounding the mosquitoes that thrived in the sometimes-stagnant water that surrounded Waikīkī. When, in October 1911, a single case of yellow fever was found aboard a ship arriving from Mexico, the Board of Health had its case made for the reclamation of the wetlands. (Courtesy Bertram Collection, Hawaiʻi State Archives.)

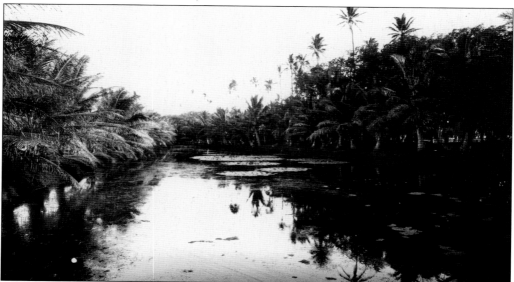

Brother Bertram captured this calm scene on Bishop Estate land in Waikīkī. In 1912, the trustees of the Bishop Estate sold to Walter F. Dillingham a large parcel of land in the nearby Kālia area; 14 families had leases on the property. Most of them were engaged in agriculture. (Courtesy Bertram Collection, Hawaiʻi State Archives.)

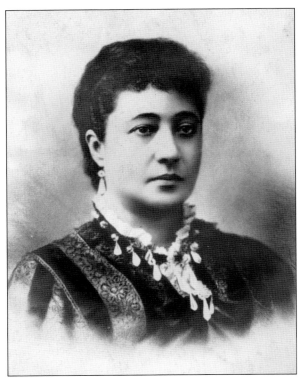

Bernice Pauahi Bishop was the great-granddaughter of Kamehameha I. She was married to businessman Charles Reed Bishop; after her death, Bishop founded Kamehameha Schools and Bishop Museum as tributes to her. The Waikīkī land she had inherited included the Kamehameha V house site. It is currently the location of the Royal Hawaiian Hotel and adjacent shopping center. (Courtesy Hawai'i State Archives.)

About 1890, Brother Bertram took this photograph of the house Kamehameha V built at Helumoa. After Kamehameha V died in 1872, his half-sister, Princess Ruth Ke'elikōlani, became the owner. By the time of this photograph, the house and surrounding land had been inherited by Princess Bernice Pauahi Bishop, who had renovated and enlarged the structure. (Courtesy Hawai'i State Archives.)

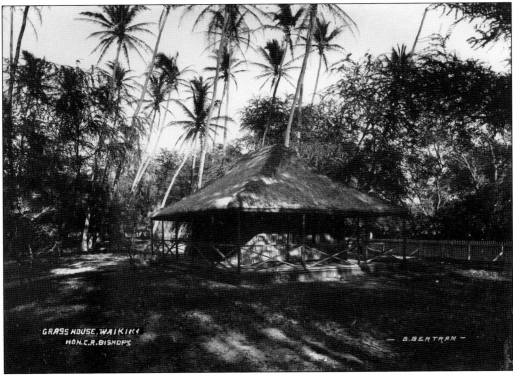

GRASS HOUSE, WAIKIKI
HON.C.R.BISHOP'S
B.BERTRAM

Originally from Glen Falls, New York, Charles Reed Bishop became the husband of Princess Bernice Pauahi Bishop in 1850. After her death in 1884, he became one of the first trustees of the vast estate that was created under the princess's will. He was instrumental in the 1887 founding of Kamehameha Schools. After 1894, he lived in San Francisco. (Courtesy Hawai'i State Archives.)

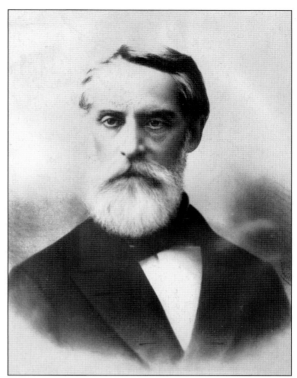

This view of the 'Āpuakēhau Stream, taken by Brother Bertram around 1890, shows how the water would form a lagoon behind the sand berm along the beach. Rice fields inland would drain into this lagoon, which would periodically fill and empty into the ocean, much to the consternation of swimmers and surfers. (Courtesy Bertram Collection, Hawai'i State Archives.)

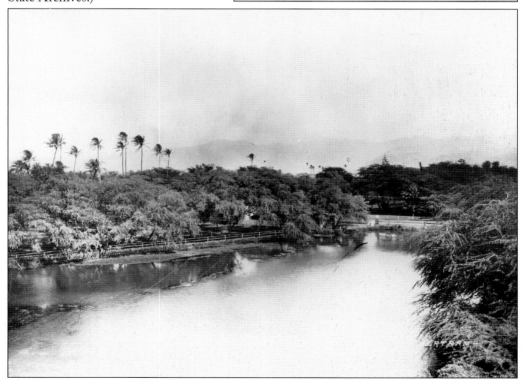

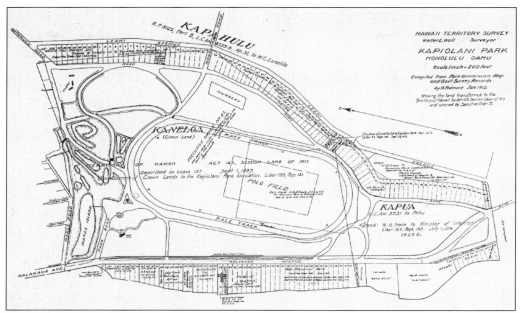

This 1912 map of Kapiʻolani Park shows the individual lots sold to shareholders of the association, as well as the extent of the donated crown lands. As president of the association for many years, Archibald Cleghorn was responsible for the landscape design of the park, as well as many other Honolulu parks. (Courtesy Jack Gilmar.)

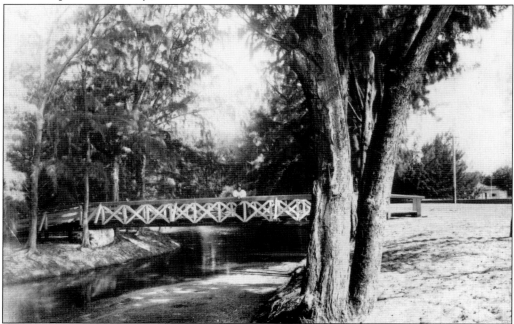

A woman stands on one of the bridges to Makee Island around 1890. The island was the location of the first Kapiʻolani Park bandstand. It was lost, along with the gentle confluence of three mountain streams and the wetland gardens of ʻĀinahau, when the Ala Wai Canal was created in the 1920s. (Courtesy Hawaiʻi State Archives.)

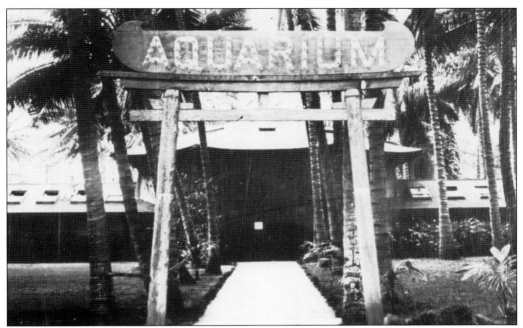

The Waikīkī Aquarium, shown here in 1904 just after it first opened, was initially created through the joint efforts of James Castle, Mr. and Mrs. Charles Montague Cooke, and the Honolulu Rapid Transit Company. Since 1919, it has been administered by the University of Hawai'i. The Waikīkī Aquarium is currently a world-renowned center for research and learning about coastal ecosystems. (Courtesy Waikīkī Aquarium.)

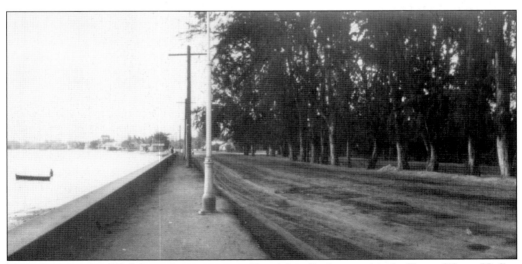

This photograph of Kalākaua Avenue next to Kapi'olani Park was taken by Roger Elmer Hefley about 1914. The grove of ironwood trees remains an important part of the park's landscape today. In the late 1930s, a public-works project would create a new beach along the seawall. In the distance along the shoreline is the Moana Hotel. (Courtesy Hawai'i State Archives.)

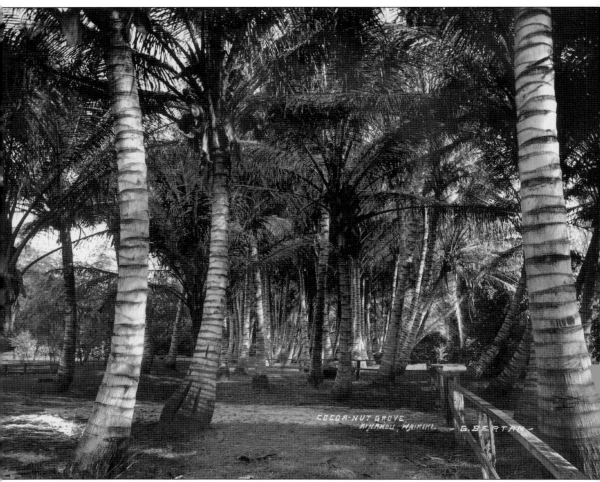

COCOA-NUT GROVE
AINAHAU WAIKIKI. — G. BERTAM

An 'Āinahau walking path carefully landscaped with coconut palms by Archibald Cleghorn is captured in Brother Bertram's lens. About half of the 11-acre estate was land that had been inherited by Cleghorn's daughter, Ka'iulani, from her aunt; the other half was bought by Cleghorn and his wife, Princess Miriam Likelike, for $300. If the area had been preserved as a park, these palms might still be standing, much like the ironwood trees lining the old carriage paths in Kapi'olani Park. Anyone who has spent an afternoon under their sweeping shade, watched a toddler scramble around their knotty trunks, or collected their tiny seed pods has received a gift that Cleghorn left for future generations. Princess Likelike, who was an accomplished songwriter, composed the song "'Āinahau" as a tribute to the estate. (Courtesy Bertram Collection, Hawai'i State Archives.)

Five

AFTER ANNEXATION
LUXURY HOTELS AND CRUISE SHIPS

The first two decades of the 20th century established Waikīkī as a destination for a relatively small group of wealthy tourists. The Moana Hotel, built in 1901, was the first establishment that offered luxury accommodations. In 1906, the Honolulu Seaside Hotel opened as a cottage-style establishment. Among its well-known early guests were Alice Roosevelt and Jack London. By the 1920s, Matson passenger ships established regular routes to Honolulu Harbor. In 1903, when the electric trolley replaced the tramcar, Waikīkī became a short 30-minute ride from downtown Honolulu.

The population of Waikīkī had become quite diversified by the 1900s, and this diversity is reflected in the participants and spectators at the First Territorial Fair, held in the summer of 1918. The calm waters of Kapiʻolani Park had yet to be drained, and the three mountain streams that wove through the wetlands had yet to be diverted. Fish and *limu* (seaweed) still filled the streams and the coastal areas.

Waikīkī was becoming synonymous with hospitality, as visitors and tourism promoters related stories of the lavish *lūʻau* feasts and the generous spirits of the locals. *Aloha* became a word associated with a fond embrace or a farewell, of visitors draped in flower *lei*, and of large crowds waiting on harbor piers. Waikīkī "beach boys" emerged as facilitators of salt-water sports and as singers of local song.

This era in Waikīkī was defined by the presence of working-class families, thriving in the close-knit neighborhoods that evolved around the Moana Hotel and that extended out toward Kapahulu Avenue near Kapiʻolani Park and Diamond Head. As Asian and Hawaiian entrepreneurs opened groceries and *lei* stands and entertained early tourists, they carried on the stewardship of the wetlands and established self-sustaining communities of their own.

But it was also a time of a burgeoning local elite. Businessmen who had grown wealthy in the sugar boom of the final decades of the 19th century had visions for Waikīkī's future that did not include agriculture or even the working class. The territorial government was actively trying to force owners of the low-lying wetlands to fill in their ponds and rice fields, ostensibly in the interest of sanitation and better public health. The U.S. Army undertook one of the first such projects when it filled in a large section of wetlands to create Fort DeRussy.

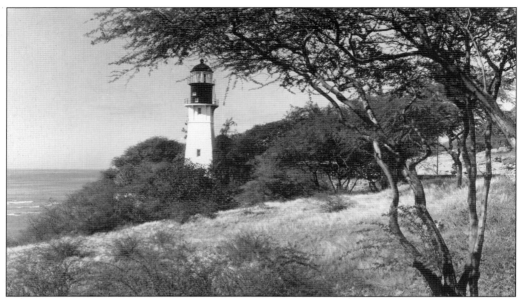

The site of the Diamond Head Lighthouse was formerly the *heiau* Pahu-o-Maui, which literally means drum of Maui. From this vantage point, fishermen could spot fish in the water below as well as give offerings to the gods for fair seas and successful fishing. By 1878, a lookout station had been built here, and in 1899, an iron and masonry structure was completed. (Courtesy U.S. Army Museum of Hawai'i.)

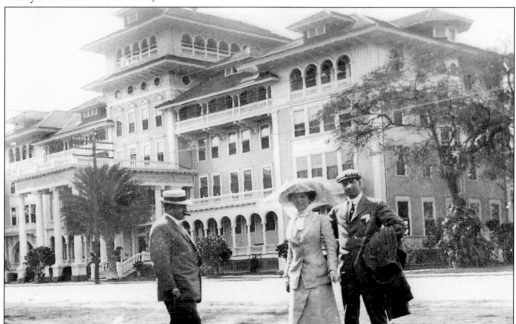

The Moana Hotel was a uniquely Hawaiian representation of the Beaux Arts style by architect Oliver G. Traphagen. The Moana expressed elements of Hawaiian regionalism such as the open-air lanai and rooftop garden. The hotel opened in March 1901 and distinguished Waikīkī as a luxury beachfront destination. (Courtesy Helen Kusunoki.)

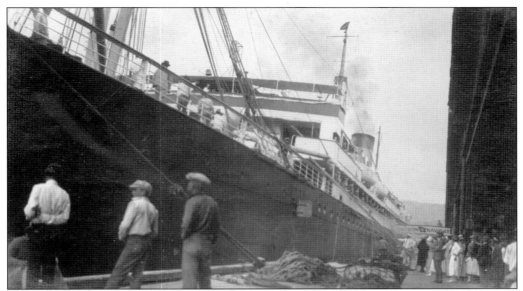

This 1924 photograph shows the arrival of the SS *Maui*, a Matson passenger steamship built in 1917 at San Francisco, California. Save for a brief commission in the U.S. Navy in 1918, the *Maui* serviced civilians visiting Hawai'i until the Depression. A trip to Hawai'i from San Francisco would take an average of six and a half days aboard the *Maui*. Most visitors to the island made the long voyage worthwhile and stayed an average of four to six weeks. (Courtesy Hawaiian Collection, University of Hawai'i, Hamilton Library.)

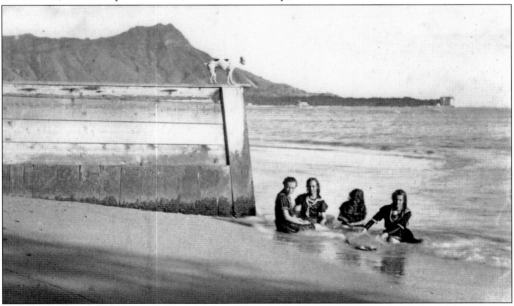

Four girls sit in the water near the Moana Hotel about 1905. Perhaps their little dog is considering joining them. Their Victorian "bathing costumes" were the common women's beach and swimming attire of the day and were normally rented from a beachside concessionaire or hotel. At the foot of Diamond Head in the background is Kainalu, the mansion built in 1899 by James Castle. (Courtesy Hawai'i State Archives.)

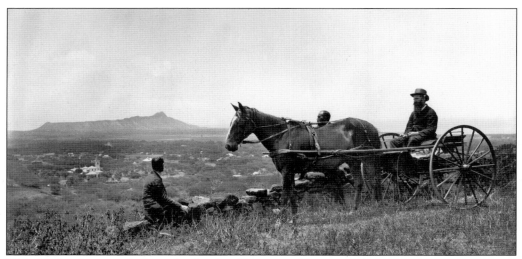

This 1890s photograph from the Brother Bertram collection shows several men taking time out to enjoy the view of early Waikīkī from the popular Punchbowl overlook. People could pay 10¢ and be taken to many inland destinations in mule-drawn trolleys. Diamond Head provides the only skyline feature in this predevelopment photograph of Waikīkī. (Courtesy Bertram Collection, Hawai'i State Archives.)

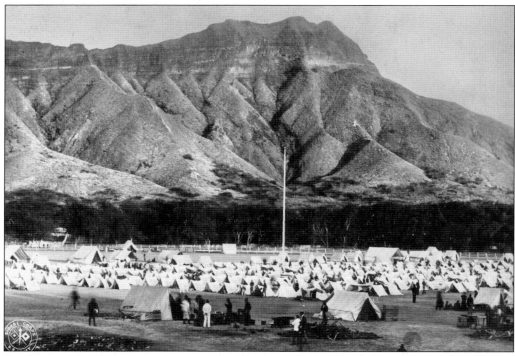

On August 12, 1898, annexation was formalized and Hawai'i became a territory of the United States. Three days later American troops occupied Kapi'olani Park en route to quell the anti-American rebellion in the Philippines. The army's camp soon became unsanitary, though, as typhoid, malaria, measles, and dysentery swept through. One entire regiment was sent home to New York. (Courtesy Hawai'i State Archives.)

Prince Kūhīo, who owned a beachfront home in Waikīkī, was a representative to the U.S. Congress for the territorial government. As foreign demand on land affected great suffering on his people, he responded by creating Hawaiian Homelands. The program, still in effect today, sets aside land for native Hawaiians. (Courtesy Hawaiʻi State Archives.)

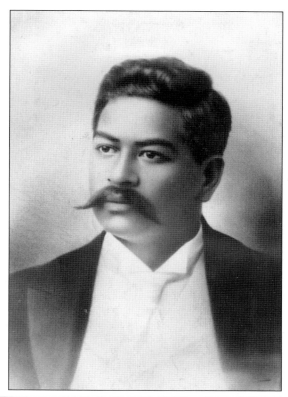

This photograph, taken by Brother Bertram from Punchbowl about 1890, shows the extent of wetland agriculture that dominated the landscape in and around Waikīkī. Note Waikīkī Road (later Kalākaua Avenue) in the background, with extensive ponds and rice fields on both sides. (Courtesy Bertram Collection, Hawaiʻi State Archives.)

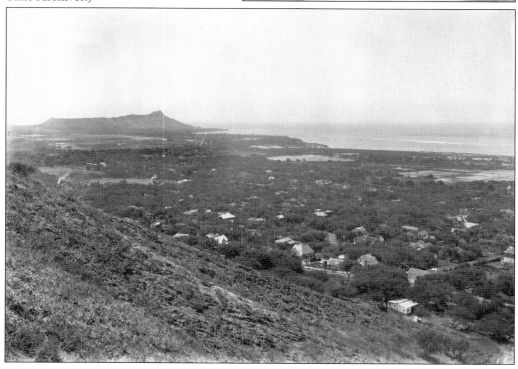

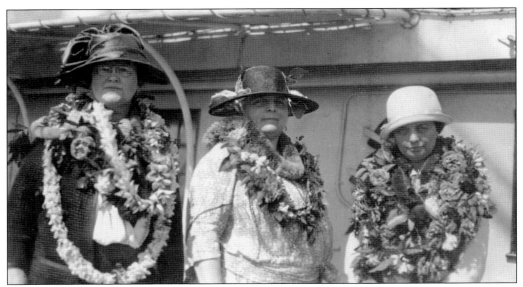

Although some people associate the customary practice of giving a flower *lei* to a visitor upon arrival in Hawai'i, it is also customary to give one upon departure, as the three women who are leaving the island show. Some believe throwing a *lei* into the water soon after leaving will portend a future return if the *lei* itself returns to shore. (Courtesy Hawaiian Collection, University of Hawai'i Hamilton Library.)

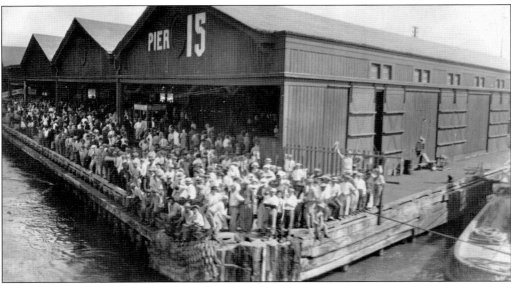

The crowd gathered at the pier for the departure of the passenger steamship shows the special distinction that travelers received when both arriving and leaving Hawaii. By the time these 1924 photographs were taken, tourism had become an important part of the economy of Waikīkī. (Courtesy Hawaiian Collection, University of Hawai'i Hamilton Library.)

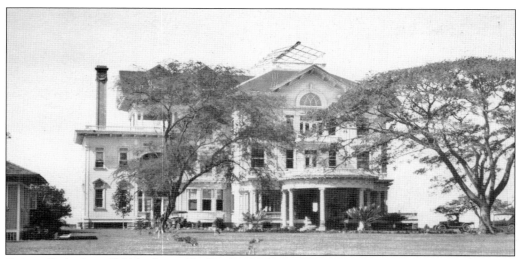

Originally built in 1899 by James B. Castle, this house, Kainalu, was bought by the Benevolent Protective Order of the Elks in 1920, after Castle's death. Castle was one of the barons of the Hawaiian sugar industry. The structure was demolished in 1959. (Courtesy Hawaiian Collection, University of Hawai'i, Hamilton Library.)

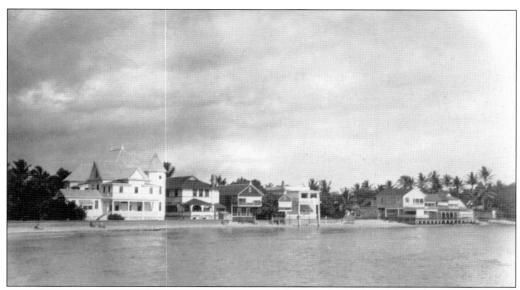

The large beachfront homes shown here, from left to right, are the Hustace Villa, the Cleghorn beach home, the Steiner residence, and the Waikīkī Tavern. The Hustace house served as an employees' annex for the Moana Hotel from 1916 to 1950. Several of these homes were later demolished to make way for the creation of Kūhīo Beach, a public beach park. (Courtesy Hawaiian Collection, University of Hawai'i, Hamilton Library.)

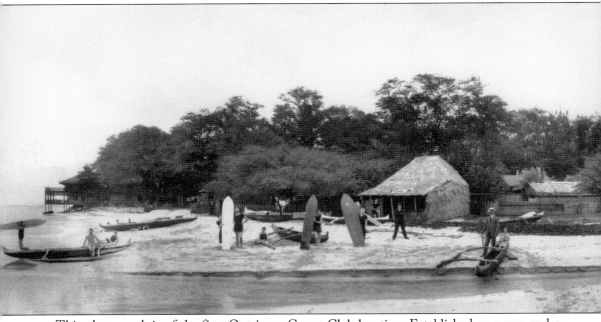

This photograph is of the first Outrigger Canoe Club location. Established on a one-and-a-half acre parcel next to ʻĀpuakēhau Stream, the club comprised two grass houses that provided changing rooms and storage space for canoes and surfboards, as well as a location for social events. Established in 1908 through the efforts of Alexander Hume Ford and a number of

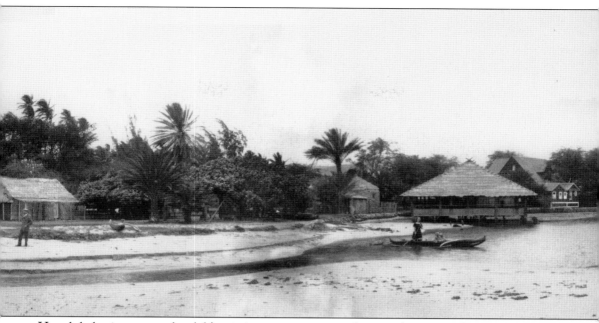

Honolulu businessmen, the club's mission was to promote the revitalization and preservation of surfing and outrigger canoeing. The club occupied several different locations in the vicinity of ʻĀpuakēhau Stream until 1964, when it was moved to the east end of Waikīkī, where it remains today. (Courtesy Hawaiʻi State Archives.)

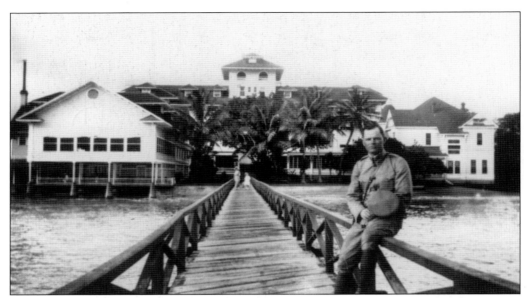

An American GI relaxes on the Moana Hotel pier around 1913. Construction of the hotel took place in the years immediately following the 1898 annexation of Hawai'i by the United States. It opened in 1901 with 75 rooms. In 1918, two wings were added, bringing the hotel's capacity to 175 rooms. The popular walking pier was deemed unsafe and was demolished in 1930. (Courtesy U.S. Army Museum of Hawai'i.)

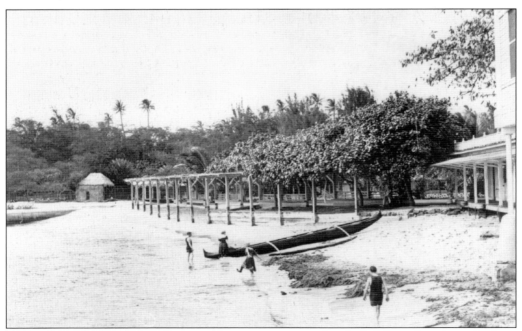

Two couples play on the beach near an outrigger canoe and a shaded *hau* arbor about 1920; in the distance is the early Outrigger Canoe Club. A small wall had been built in an attempt to control the outflow of the 'Āpuakēhau Stream, the waters of which flowed through agricultural areas nearby. (Courtesy Hawai'i State Archives.)

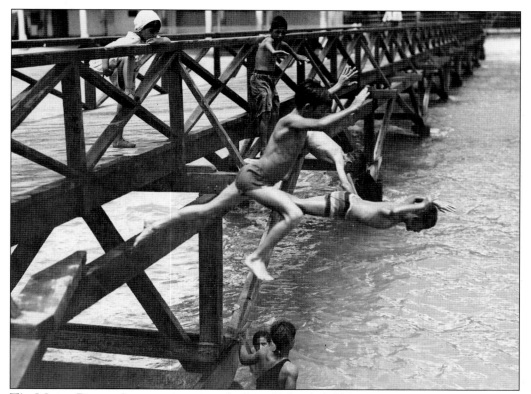

The Moana Pier made a great jumping platform for local children enjoying a swim in the warm Pacific waters. These kids likely lived in one of the working-class homes that were still a part of thriving Waikīkī neighborhoods in the 1920s and 1930s. (Courtesy Hawai'i State Archives.)

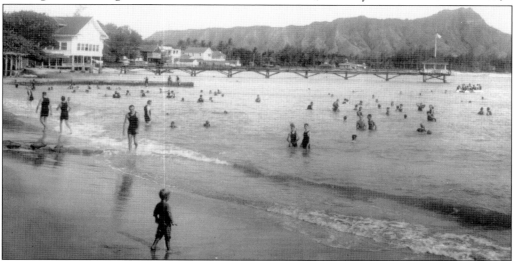

This 1920s view of Waikīkī shows a toddler getting his feet wet. For the most part, these vacationers represent the mainland elite who could afford the accommodations at Waikīkī's Moana Hotel as well as the travel time, a six-and-a-half-day trip from San Francisco. (Courtesy Hawai'i State Archives.)

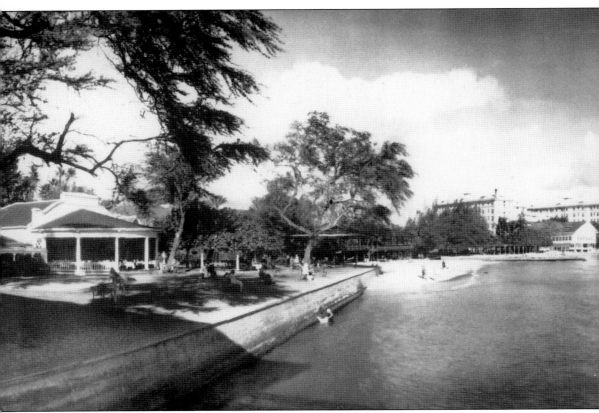

The Honolulu Seaside Hotel (left) was built in 1906 after businessman George MacFarlane acquired both the Hawaiian Annex bathhouse and the adjacent royal coconut grove at Helumoa. The Annex remained a part of the Seaside grounds, which featured cottages and tent houses nestled among the trees along its 10-acre beachfront site. The Seaside enjoyed almost two

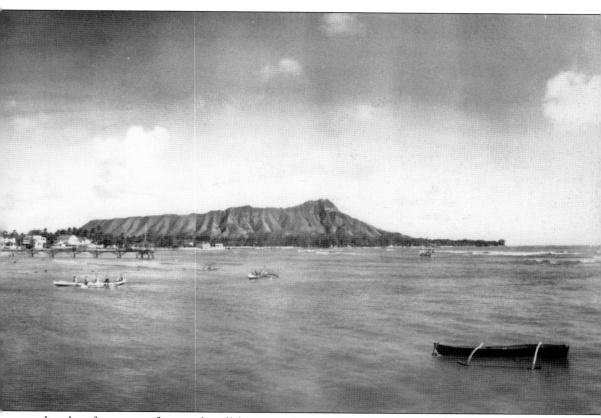

decades of patronage from such well-known visitors as Alice Roosevelt and Jack London. When it closed in 1925, some of the cottages were razed, while others were relocated where the Princess Ka'iulani Hotel stands today. Two years later, the area became the site of the Royal Hawaiian Hotel. (Courtesy Hawai'i State Archives.)

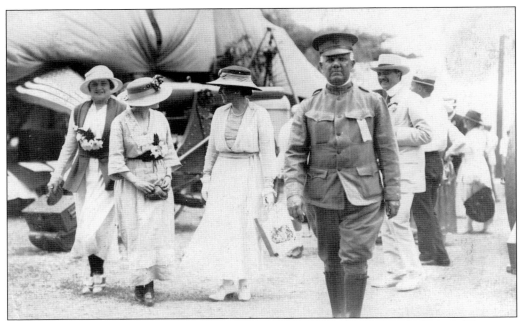

Honolulu's first territorial fair was held at Kapiʻolani Park from June 10 to 15, 1918. The event featured agricultural and livestock displays, athletic competitions, horse races, band concerts, and moving pictures. There was also a rodeo and a Japanese tea garden. It was the kind of event that King Kalākaua likely had in mind when he preserved the park as a community resource four decades earlier. (Courtesy Hawaiʻi State Archives.)

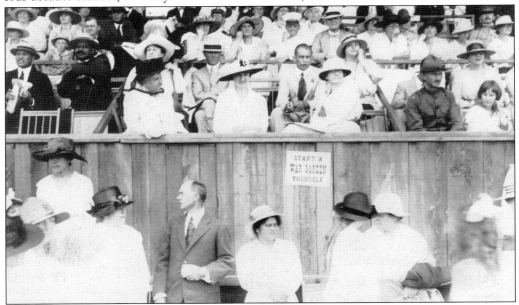

When the 1918 Territorial Fair took place, it was still five months before the end of World War I, as the sign on the bleachers, "Start a War Garden Now," attests. One can see Prince Kūhiō in the bleachers (the gentleman with the mustache, second from left). (Courtesy Hawaiʻi State Archives.)

A large contingent of U.S. Army personnel participated in the athletic events, including track and field and aquatics. By 1918, there already were numerous army bases on Oʻahu, including Fort DeRussy in the Kālia area of Waikīkī, which was for the most part a coast artillery station. (Courtesy Hawaiʻi State Archives.)

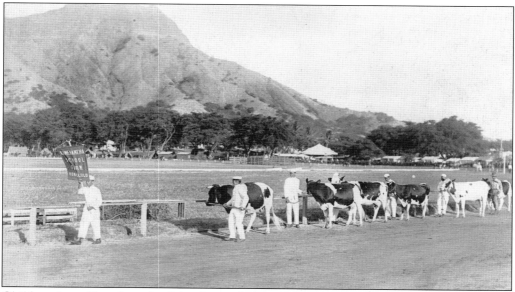

Children from Kamehameha Schools parade livestock they have been raising. Kamehameha Schools was founded in 1887 by the Bishop Estate expressly for the education of children of Hawaiian ancestry. The Bishop Estate, which owns a considerable portion of the real estate in Waikīkī, is the largest private landowner in Hawaiʻi. Today Kamehameha Schools has over 6,500 students on numerous campuses across the state. (Courtesy Hawaiʻi State Archives.)

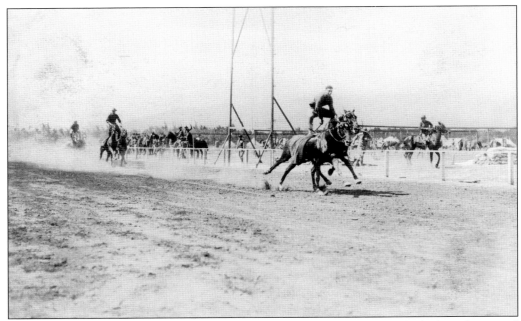

Among the most exciting races at the fair was the Roman Riding, in which the riders stand with one foot on each of two bareback horses. Horse racing and polo were common events at Kapiʻolani Park in this period. The fair also included more conventional horse races as well as a chariot race. (Courtesy Hawaiʻi State Archives.)

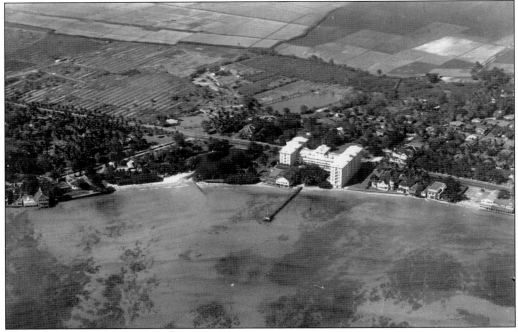

This 1920 photograph shows ʻĀpuakēhau Stream and the Moana Hotel, as well as a large pond and rice fields. The lagoon, stream, ponds, and rice fields would soon be filled to make way for more hotels and real estate development. (Courtesy U.S. Army Museum of Hawaiʻi.)

Six

DREDGING AND FILLING
THE END OF AGRICULTURE

The building of the Ala Wai Canal forever changed the landscape of Waikīkī. Known officially as the Waikīkī Reclamation Project, the construction involved three stages of engineering: draining, dredging, and filling. The previous chapter shows Waikīkī as a place of wetland agriculture, where streams and rivers were integrally tied to the work and recreation of the community. The construction of the Ala Wai Canal represented a paradigm shift; the community that had been centered on subsistence agriculture became increasingly dependent on an urbanized tourist industry.

The annexation of Hawai'i by the United States in 1898 meant that the governor was appointed by the president of the United States. The most influential governor in the years leading up to the reclamation project was Lucius E. Pinkham. A former president of the Territorial Board of Health, Pinkham had an urban vision for Waikīkī. This vision was first laid out in a 1906 board of health report wherein Pinkham described Waikīkī as "insanitary [sic]" and "deleterious to the public health." Liens were placed against landholders, mostly Chinese, who could not afford to or would not drain the ponds and rice fields that were their livelihood. Pinkham's vision for an urbanized Waikīkī that catered to the elite became a reality with the dredging and filling of the "place of spouting waters."

Pinkham's connection to Walter F. Dillingham, real estate developer and owner of Hawaiian Dredging Company, was central to his influence on the future environment of Waikīkī. Public health reports also influenced Waikīkī's reclamation, contributing to fears that mosquito populations that thrived in the low-lying wetland areas harbored infectious disease. As trade was increasing with Mexico, where yellow fever was found, the threat of outbreak was not unwarranted. Whether or not the forced land reclamation and removal of people's livelihood was the proper response to these problems may be reflected on in the following chapter.

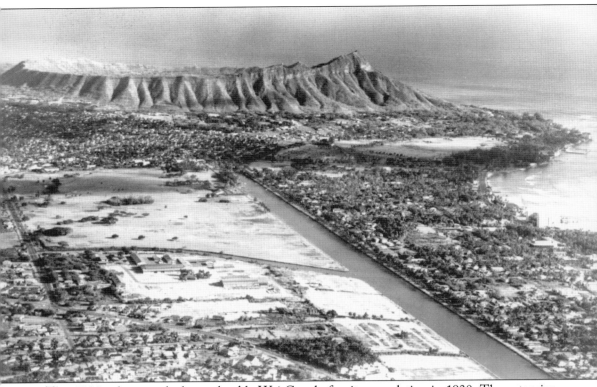

This 1930s photograph shows the Ala Wai Canal after its completion in 1930. The extensive dredging and filling known as the Waikīkī Reclamation Project transformed an elaborate agricultural network consisting of fishponds and rice and taro farms, as well as banana and coconut groves, into hundreds of acres of real estate for homes and hotels. The expanse of white area that appears to the left of the canal had been filled with material from the dredging. This area, although mostly open space in this photograph, would become the site of many high-rise apartment complexes such as the Bel Air and the Rosalei by the early 1960s. Today large, upscale condominiums, including the Marco Polo, occupy much of the area along Kapiʻolani Boulevard. (Courtesy Camera Hawaiʻi.)

Lucius E. Pinkham was both president of the Territorial Board of Health and the governor of Hawai'i. His 1906 Pinkham Report encouraged the urbanizing and homogenizing of Waikīkī's culture and community to support the lifestyles of the elite. (Courtesy Hawai'i State Archives.)

Earle "Liko" Vida, who grew up alongside the Pi'ianaio Stream in the Kālia area, remembers that the area "was nothing but duck ponds. In fact, all the area down here in Kālia was practically duck ponds. And we lived either on the ocean or alongside of a river or a duck pond." The Kālia area is now the site of the largest retail center in Hawai'i: Ala Moana Shopping Center. (Courtesy Hawai'i State Archives.)

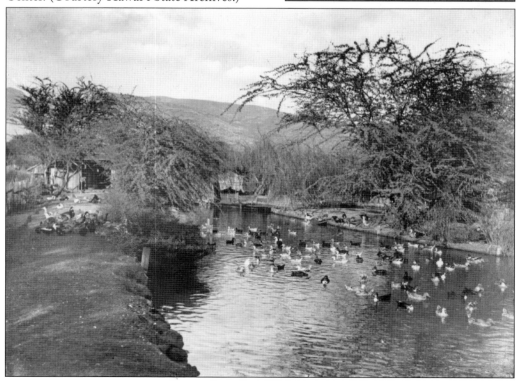

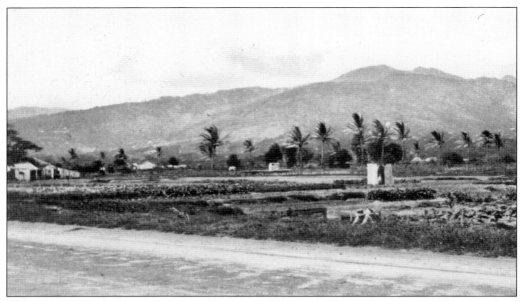

Governor Pinkham stated in his 1906 report: "Honolulu desires a population, omitting the consideration of agriculturalists. . . . Persons and residents of private fortune, who seek an agreeable climate and surroundings, who expend large already acquired incomes rather than those who expect the community to furnish them the opportunity of earning a livelihood. Such persons as we seek desire to find attractive and charming residential districts free from all objectionable features and neighbors." (Courtesy Hawai'i State Archives.)

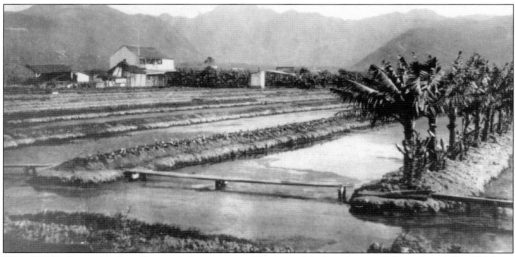

This Waikīkī agricultural scene showing sophisticated irrigation and functional footbridges would soon be eliminated when the vision of the governor was realized following the Pinkham Survey of 1917–1918. Following the survey, all areas less than 6 feet above sea level faced condemnation unless landholders would drain and fill their ponds and rice fields. (Courtesy Hawai'i State Archives.)

This 1920 photograph captures duck ponds behind Waikīkī. Chang Fow was a local farmer who raised ducks and fish in ponds such as these. In May 1922, Fow wrote a letter to the Bishop Trust Company describing his hardship after the complete devastation wrought on his farm by the dredging. In June 1923, Fow and his family of seven were awarded a single payment of $250 by Hawaiian Dredging Company for the loss of the farm. (Courtesy Hawai'i State Archives.)

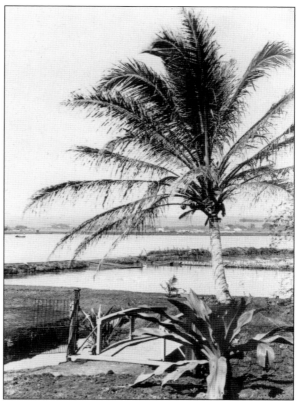

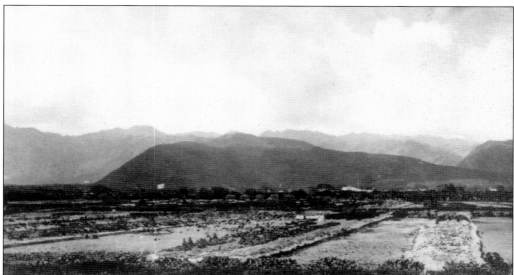

This photograph was taken by Roger Elmer while he was stationed at Fort DeRussy from 1914 to 1915. Taken from Kalākaua Avenue looking toward Wa'ahila Ridge and Mānoa Valley, it reveals an expanse of agricultural land now lost to development. In only a few short years, land such as this open acreage in Waikīkī would be sold by the square foot. (Courtesy Hawai'i State Archives.)

Walter F. Dillingham obtained his first dredge and established the Hawaiian Dredging Company in 1902. But dredging and filling land was not his only business. By 1915, he owned 145 acres of land within the area of Waikīkī designated for reclamation. After the area was improved, Dillingham would profit from the sale and subdivision of this property for real estate development. (Courtesy Hawai'i State Archives.)

In 1881, Rev. Serano E. Bishop, as part of the Hawaiian Government Survey, created this map showing 15 ponds and numerous streams that composed a large portion of Waikīkī. The outline of the Ala Wai Canal, which was completed in 1923, was added to this version of the map in 1952. (Courtesy Hawai'i State Archives.)

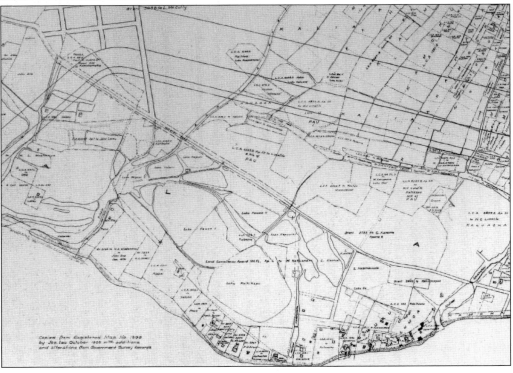

Initially proposed in 1906, construction on the Ala Wai Canal began in 1921. This photograph shows the dredge Kewalo cutting across Kalākaua Avenue. The width of the completed canal was 250 feet, and the dredged material was used to fill over 150 acres of wetland devoted to agriculture and aquaculture. (Courtesy Hawai'i State Archives.)

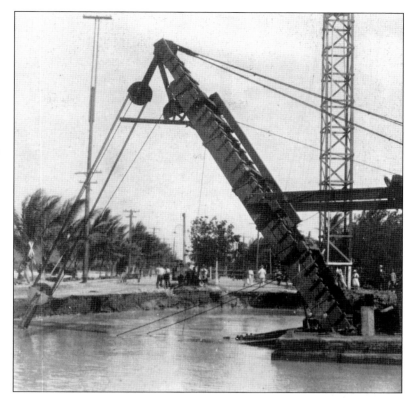

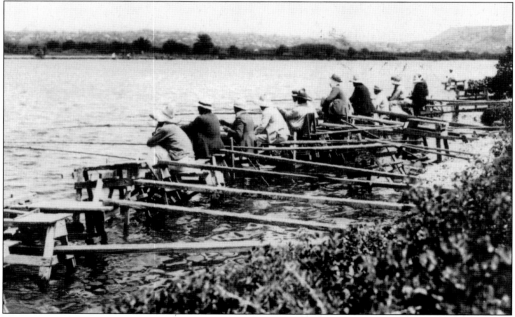

This 1930s photograph shows how a group of local residents continued to fish in the waters of Waikīkī, even though they were now part of the Ala Wai Canal. In the left rear of the photograph, workers can be seen building the wall along the canal. (Courtesy Hawai'i State Archives.)

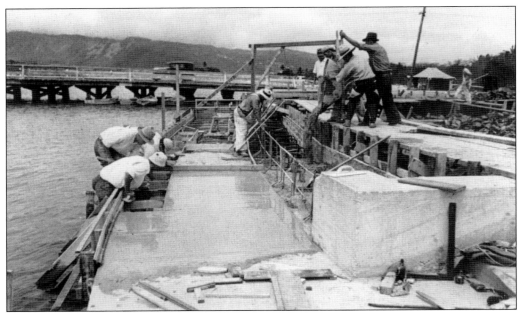

In 1934, President Roosevelt's New Deal reached Hawai'i and the reclamation project in the form of Civilian Conservation Corps crews that built improvements to the canal. A crew is shown here constructing a concrete wall that can still be seen today along the banks of the Ala Wai Canal. The photograph also shows a length of the completed wall and a stairway for access to the water. (Courtesy Hawai'i State Archives.)

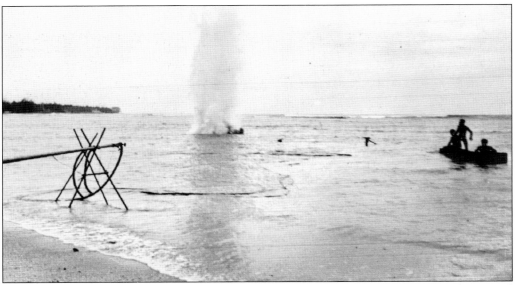

Civilian Conservation Corps crews were involved in a large coral-extraction project that mined coral reefs, extracting the coral and using it as fill for the Ala Moana Beach Park and the future Ala Moana Shopping Center. In this photograph, workers watch as dynamite sprays sea water and severs coral from the reef. (Courtesy Hawai'i State Archives.)

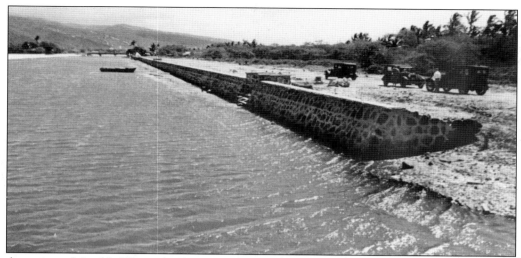

A portion of the Ala Wai embankment wall is shown after its completion in 1934. These walls would go down in municipal-disaster history during the massive flooding of April 2006 that resulted in a sewer main breakage in Waikīkī. Mayor Mufi Hanneman's decision to reroute the sewage into the Ala Wai Canal and eventually to the ocean, instead of letting it back up in the streets of Waikīkī, was a controversial one. (Courtesy Hawai'i State Archives.)

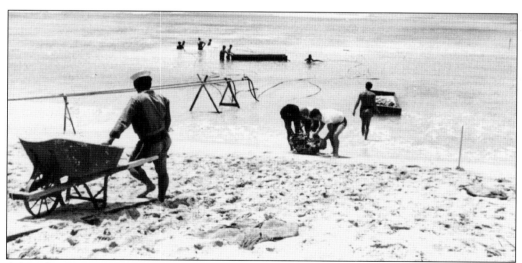

After the coral was broken into rubble, it had to be extracted from the ocean. This was a painstaking process that involved loading it onto wooden skiffs and hauling it to shore. It was then moved up the beach in a wheelbarrow and hauled away to be broken into spreadable fill. (Courtesy Hawai'i State Archives.)

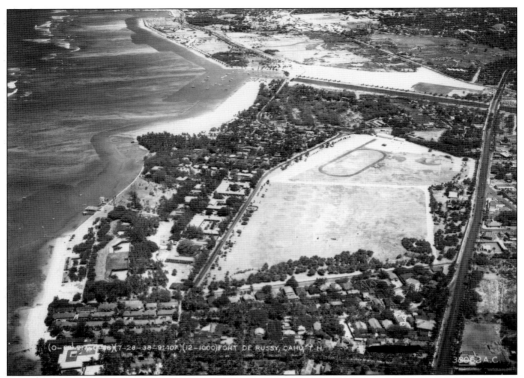

This 1930s aerial photograph shows the Fort DeRussy area and the mouth of the Ala Wai Canal. Also shown is the immense amount of dredging that had taken place along the shoreline. In the lower left corner is Battery Randolph, where the U.S. Army Museum of Hawai'i is now located. (Courtesy U.S. Army Museum of Hawai'i.)

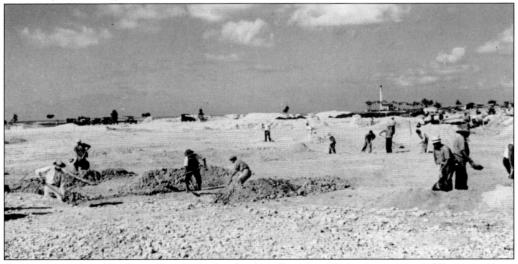

Once the coral was broken down, it had to be distributed to fill in the wetland. The crews here demonstrate that Civilian Conservation Corps projects were usually characterized by manual labor. In the background of the right side of the photograph, the incinerator tower is visible through the palm trees. (Courtesy Hawai'i State Archives.)

Members of the Outdoor Circle plant trees along the Ala Wai Canal about 1935. Founded by a group of women in 1912, the organization is dedicated to "preserving, protecting and enhancing Hawai'i's scenic environment for future generations." Thanks to the organization, Waikīkī is free from billboards and other obtrusive advertising. (Courtesy Hawai'i State Archives.)

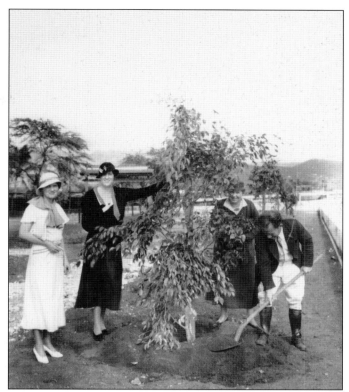

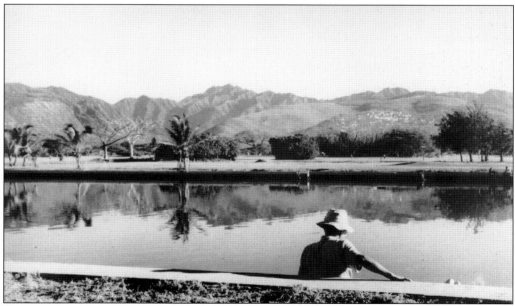

A man takes a quiet moment of reflection along the Ala Wai Canal. Although the canal brought many changes to traditional farming and life in Waikīkī, it has become a part of the urban landscape whose scenic qualities still provide some with a place for relaxation. (Courtesy Hawai'i State Archives.)

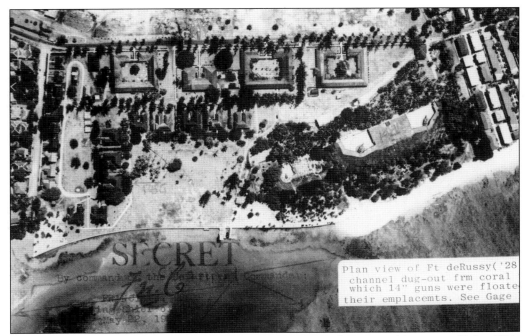

Plan view of Ft deRussy('28
channel dug-out frm coral
which 14" guns were floate
their emplacemts. See Gage

Between 1904 and 1915, the U.S. War Department acquired just over 72 acres in Kālia. This was done by way of both purchases and condemnation proceedings sanctioned by executive order. From ancient times, this area had been the site of an extensive fish, taro, and duck pond complex. Approximately 250 million cubic yards of coral and sand were used to fill the ponds. The site also included the estate of Chun Afong. Originally called the Kalia Military Reservation, it was renamed Fort DeRussy in 1909 to honor Brevet Brig. Gen. Rene Edward DeRussy, who had served in both the War of 1812 and the Civil War. There were originally three artillery batteries, one of which, Battery Randolph, today holds the U.S. Army Museum of Hawai'i. The "secret" aerial photograph above dates from the 1920s. The historic entryway, shown below in the mid-1930s, has since been lost. (Courtesy U.S. Army Museum of Hawai'i.)

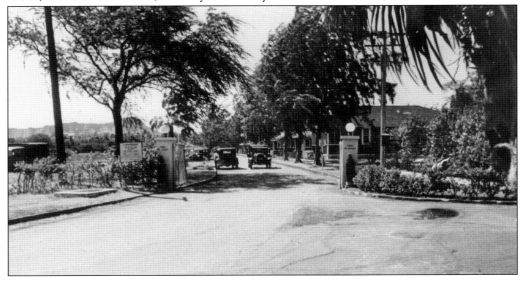

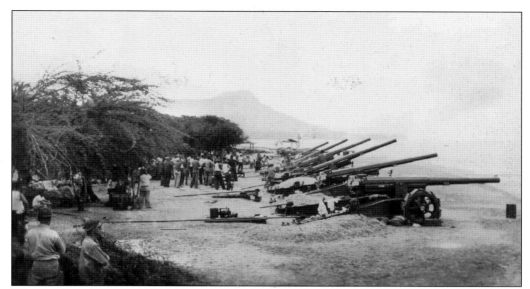

This artillery battery at Fort DeRussy is preparing for target practice. A target barge would be towed along some distance offshore. The artillery installed at Fort DeRussy, including a number of 14-inch cannons, were never used during hostility. (Courtesy U.S. Army Museum of Hawai'i.)

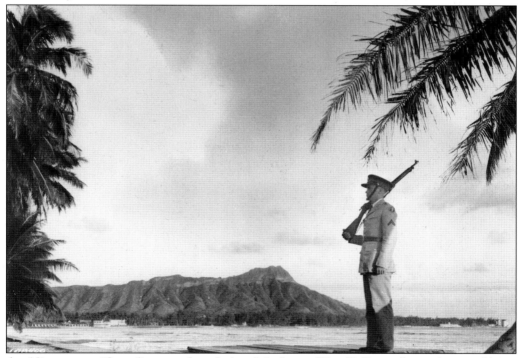

A soldier poses as if standing guard on the beach in front of Fort DeRussy for a military publicity photograph. The War Memorial Natatorium and the Castle mansion (far right) date this view in 1927. By the end of the year, the Castle mansion would be razed. (Courtesy U.S. Army Museum of Hawai'i.)

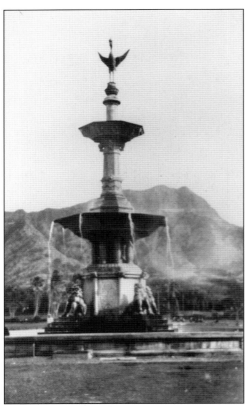

The Phoenix Fountain, built by Japanese immigrants and dedicated in 1919 to Human Brotherhood, was torn down in December 1942, one year after the Japanese attack on Pearl Harbor. In 1950, the City and County of Honolulu built a smaller one in the same location, which in 1967 was replaced with the current Dillingham Fountain. (Courtesy U.S. Army Museum of Hawai'i.)

The Beach Cleaners, pictured here some time in the 1930s, offered dry cleaning and laundry services to locals as well as the many servicemen in the area. It was located in the Kālia neighborhood less than a five-minute walk from Fort DeRussy, near the present site of the Ala Wai Yacht Harbor. (Courtesy Hawai'i State Archives.)

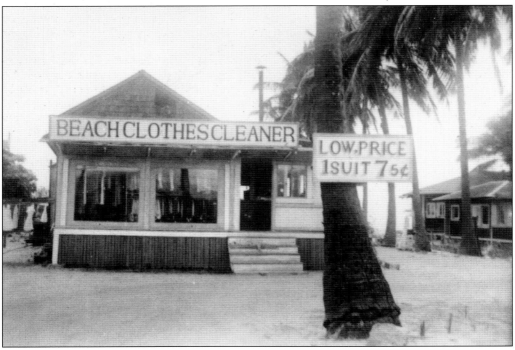

Seven

Suburbanizing the Landfill

From Rice Fields to Apartments

By the 1930s, the beach area around the mouth of the former ʻĀpuakēhau Stream, where Hawaiian kings had lived and where an important religious site once stood, had become the location of two of the most prestigious hotels in the United States. By this time, all of the wetlands in Waikīkī had been filled and graded. The landscape was ready for full-scale transformation into a suburban residential development.

But it was not until after World War II that major new hotels or apartment buildings would be constructed. In the decades between the two World Wars, Waikīkī experienced a period when residential home lots could be purchased. In many of the areas surrounding these new homes stood other more modest homes of Japanese, Chinese, and Hawaiian people who worked in the hotels or in other capacities in support of the community.

During the 1930s, federal money, part of President Roosevelt's New Deal, made its way to Waikīkī in the form of public works projects. These included the building of walls along the Ala Wai Canal and the ongoing filling of low-lying areas by taking coral out of the reef, either by dredging or by other means. The creation of Kūhīo Beach took place in 1939 by hauling some 38,000 cubic feet of sand from Waimānalo, on the other side of the island. And at the other end of Waikīkī, in the former Kālia area, the filling allowed for the creation of Ala Moana Beach Park.

Because workers in many important areas of the Hawaiian economy, including hotels, were in need of better pay and working conditions, unions began to be organized, and for Waikīkī, this meant the organization of the bartenders and hotel workers. This was done in large part through the efforts of Arthur Rutledge, who began organizing Local No. 5 and negotiated a union contract for workers at the Royal Hawaiian Hotel in 1941. By the early 1960s, the union was strong enough to develop its own high-rise. Rutledge was highly respected by the hotel owners, and consequently there were few strikes by union workers.

As Waikīkī changed from an agricultural area to a resort area, so did the community that supported this change. As jobs revolving around the growing tourism increased, people came to fill this new sector of the service industry.

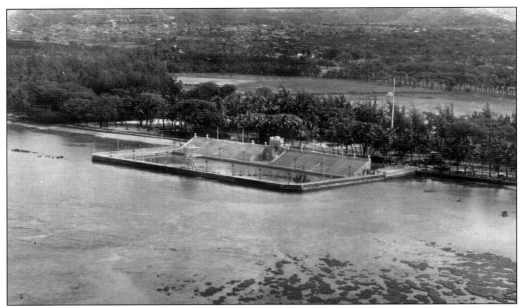

Considered to be an important expression of the Beaux Arts style, the Waikīkī War Memorial Natatorium was built as a "living memorial" to honor the 102 Hawai'i servicemen killed in World War I. The 100-meter saltwater aquatics center opened in 1927 with an Amateur Athletic Union national championship competition. Olympic swimmers Duke Kahanamoku, Clarence "Buster" Crabbe, and John Weissmuller all competed in the event. It was for many years the center of swimming competition in Hawai'i. During World War II, the military used it for training; afterwards, it was returned to general public use. But deterioration from salt water, along with governmental neglect, caused the pool to fall into disrepair. It was closed to public use in 1978, and over the next 20 years, the structure continued to languish. In 1995, the National Trust for Historic Preservation included the natatorium in its annual list of the 11 most endangered historic places. In 2001, the natatorium's facade was restored, but the pool itself remains unusable. (Courtesy Hawaiian Collection, University of Hawai'i.)

Duke Kahanamoku repeated his 1912 gold medal performance at the 1920 Antwerp Games, and at the 1928 Paris games, he won a silver medal in the same event. His powerful stroke can be seen in this photograph, taken in 1932 in Los Angeles. (Courtesy Library of Congress.)

Duke Paoa Kahanamoku—a bronze statue of whom now stands next to Kalākaua Avenue at Kūhiō Beach—skyrocketed to fame in 1911, when he dramatically broke world swimming records at the first Amateur Athletic Association meet in Hawai'i. In 1912, when this photograph was taken, Kahanamoku astounded the world by winning a gold medal in the 100-meter freestyle at the Stockholm Olympics. As an international celebrity, Kahanamoku was a tireless ambassador for Hawai'i. (Courtesy Library of Congress.)

The photograph below shows Duke with other members of the 1920 U.S. Olympic Swim Team. From left to right are the following: (first row) "Wild Bill" Harris, Helen Moses Cassidy, and Pua Kealoha; (second row) Warren Kealoha, Ludy Langer, Duke Kahanamoku, and Dad Center (coach). (Courtesy Hawai'i State Archives.)

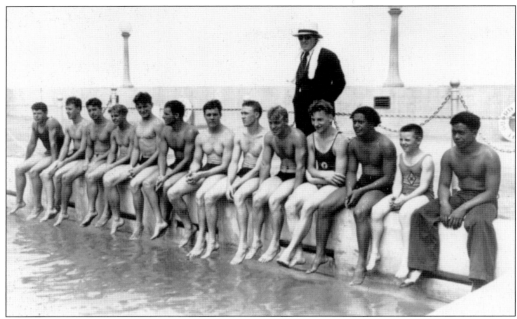

During its heyday, the natatorium was the venue for numerous swimming contests. Local and visiting swim teams, along with world-famous Olympic competitors, would look forward to racing in the 100-meter salt-water pool. Here, about 1930, a group of young competitors pose with their coach. (Courtesy Hawai'i State Archives.)

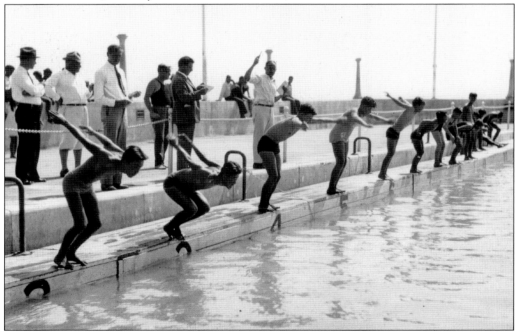

Caught in the moment after the starting gun has sounded, these young swimmers are competing at the natatorium around 1930. The second boy from the left seems to have the best start. Numerous swimming records were set at this pool. (Courtesy Hawai'i State Archives.)

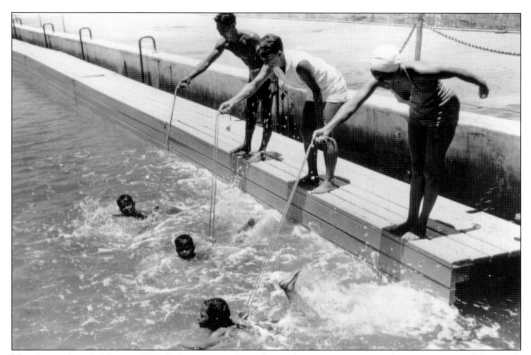

Teaching the children of Waikīkī to swim has always been a priority in the community. Through the 1930s, the natatorium served as a primary location for organized swimming classes. These children are tethered to their teachers, who are trying to persuade them to coordinate their arms and legs in the right way. (Courtesy Hawai'i State Archives.)

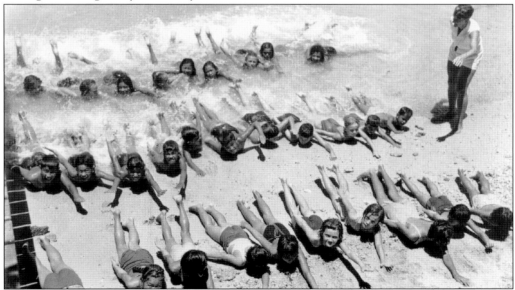

Prior to swimming in the pool, children were given instruction on the sand, where small waves would wash up around them and allow them to float, if only for a few moments before the wave would recede. Much of the sand around the natatorium was brought in from elsewhere. (Courtesy Hawai'i State Archives.)

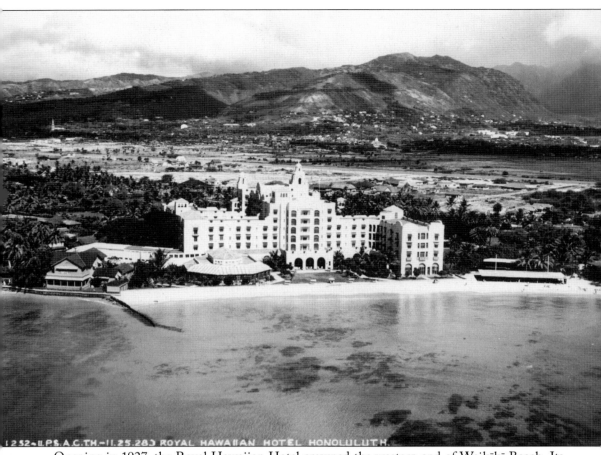

1252-II P.S. A.C. TH-II.25.28 J ROYAL HAWAIIAN HOTEL HONOLULU.T.H.

Opening in 1927, the Royal Hawaiian Hotel crowned the western end of Waikīkī Beach. Its luxurious accommodations solidified the reputation of Waikīkī as a resort destination. With 400 rooms, it effectively doubled the number of hotel rooms previously available to tourists. Planned and built by Capt. William Matson largely for passengers of his luxury steamship liner, the *Mālolo*, the Royal offered rooms at $14 a night in 1929. Architects Warren and Wetmore of New York City were influenced by Spanish and Moorish styles and the color tastes of the Roaring Twenties—hence the bright pink exterior. For its unique character, the Royal Hawaiian Hotel enjoys the prestige of being on the National Register of Historic Places. (Courtesy U.S. Army Museum of Hawai'i.)

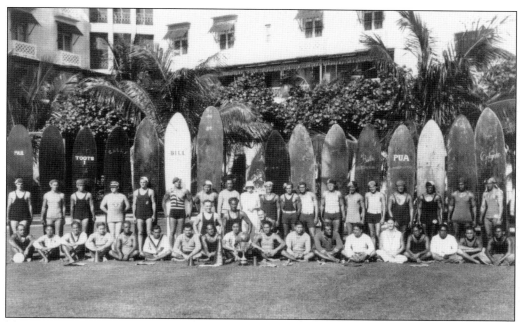

This 1930s photograph shows a group of beachboys after a surfboard water-polo match posing on the lawn of the Royal Hawaiian Hotel with two tourists. Beachboys gave surfing lessons, served as lifeguards, and generally helped tourists relax and enjoy the beach. Included in this photograph is Duke Kahanamoku (kneeling center). (Courtesy Hawai'i State Archives.)

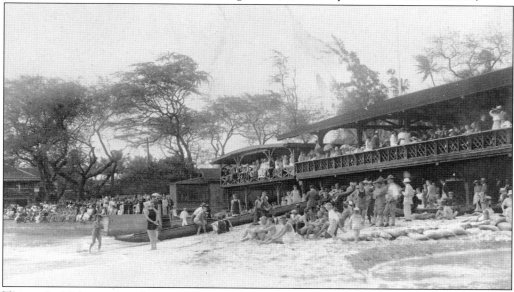

This early-20th-century photograph of the Outrigger Canoe Club shows a large crowd, probably gathered for a canoe regatta. When the Ala Wai Canal diverted the 'Āpuakēhau Stream (bottom right), the superintendent of public works reported, "the canal has now intercepted 'Āpuakēhau Stream which flowed by the Outrigger Club and all of the filthy waters which previously flowed on to this fine swimming beach have been diverted and now flow out to sea." (Courtesy U.S. Army Museum of Hawai'i.)

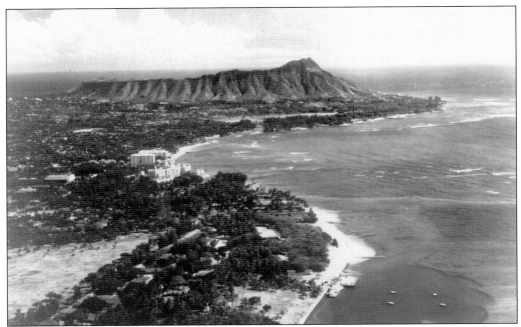

This 1940 photograph shows Fort DeRussy in the foreground, with its dredged-out swimming area and parade field. Also shown are the Royal Hawaiian and Moana Hotels, and in the background is Kapiʻolani Park. This is an excellent overview of Waikīkī prior to the massive and ongoing post–World War II construction boom. (Courtesy Hawaiʻi State Archives.)

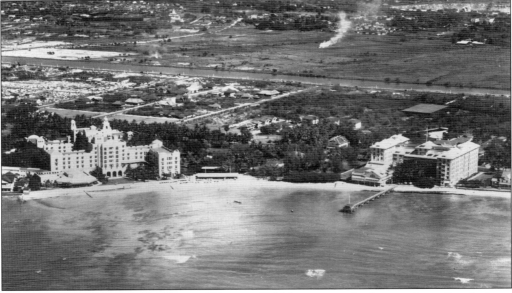

This aerial view of Waikīkī taken in February 1930 juxtaposes the last vestiges of agriculture with the burgeoning real estate development that still lay ahead for Waikīkī. Before the year was out, the Moana Pier, still visible here, would come down and the price of real estate in Waikīkī would begin to skyrocket. (Courtesy Hawaiian Collection, University of Hawaiʻi, Hamilton Library.)

St. Augustine Catholic Church, located just off Kalākaua Avenue near Kapi'olani Park, was built in 1901 with the aim of serving residents, U.S. soldiers encamped at Kapi'olani Park, and more conventional tourists staying at the newly opened Moana Hotel and elsewhere. (Courtesy Hawai'i State Archives.)

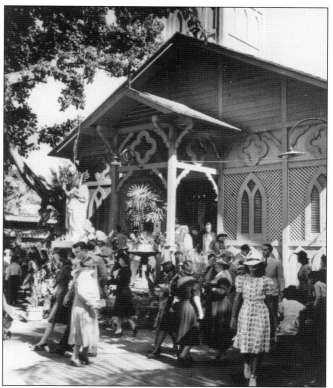

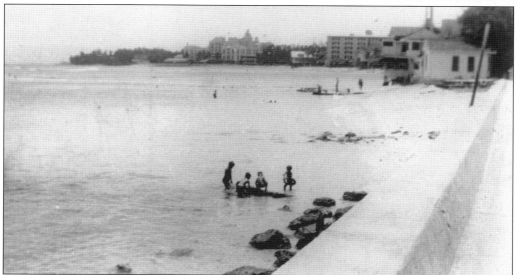

Although the urban area of Waikīkī has been largely privatized in the form of exclusive hotels and expensive boutique shops, the beach remains public. Therefore, a scene like this 1930s view of children playing in the water is still very common today. That the beach is open and free to all is largely due to the work of William S. Richardson, state supreme court justice from 1966 to 1982, who stated, "the western concept of exclusivity is not universally applicable to Hawai'i." (Courtesy U.S. Army Museum of Hawai'i.)

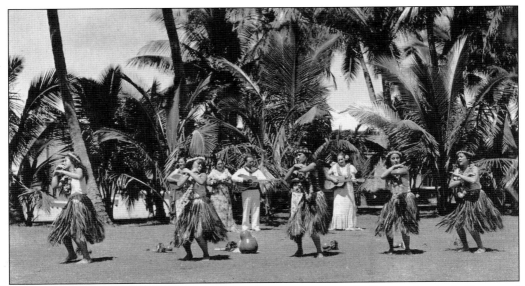

Hula—the traditional dance of Hawaiian culture—went into decline under the influence of Calvinist missionaries, then it revived itself in the late 19th century. Much of the *hula* performed in Waikīkī has been modified to suit the tastes of tourists and is referred to as *hula 'auana*, which is accompanied by singing, sometimes in falsetto, as well as by guitar and ukulele playing. (Courtesy U.S. Army Museum of Hawai'i.)

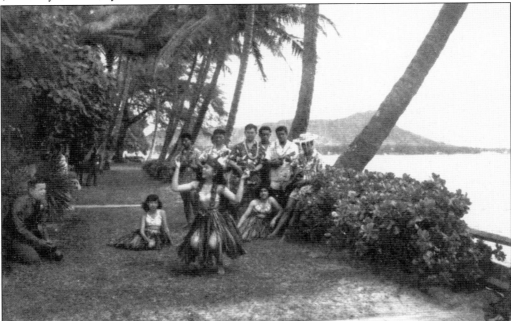

The most traditional and authentic form of the hula is called *hula kahiko* and is usually done to accompany *mele*, or chants. Performances often recount the mythology of traditional Hawai'i and depict an intense interaction with nature. Numerous *hula halau*, schools where *hula* and other Hawaiian cultural practices are taught, can be found today throughout Hawai'i and elsewhere. (Courtesy Vince Sortino.)

Eight

ORAL HISTORIES

TALKING STORY ABOUT OLD WAIKĪKĪ

The stories and photographs in the following chapter come from longtime residents and business owners who lived and worked in Waikīkī in the early 20th century. Many of them can remember a time before skyscrapers, traffic jams, and tourist shops. Over a two-year period, the University of Hawai'i at Manoa's Center for Oral History conducted personal interviews in a casual "talk story" (the popular local Hawaiian phrase for everyday conversation) fashion. The stories are often told in pidgin, the Creole-English of the islands, and quotations appear as they were spoken.

Many of the interviewees lived a life closely connected to the vestiges of the wetland waterways left by the native Hawaiians. Sadao Hikida remembers her family's connection to 'Āpuakēhau Stream: "There was a pond by our home which was connected to the 'Āpuakēhau Stream. It was filled with shrimps and small fishes. And it was where we raised our ducks." John C. Ernstberg remembers when even the shallow ocean waters of Waikīkī teamed with fish: "At nights, we used to come on top the reef here, reef down Kālia, we catch the little red fish they call *'ala'ihi.*"

All of the memories shared in this oral-history section come from people who knew Waikīkī before it was urbanized. Sadao Hikida reflects on the rural character of Waikīkī: "Waikīkī was a place of beauty and tranquility . . . [you] could smell the sweet fragrance of the flowers when the breezes blew and see the beautiful rainbow over Mānoa Valley and the ocean [unobstructed by buildings]."

Many had lived in Waikīkī during World War II and remembered the changes it brought to Waikīkī residents. "We had to be home [curfew]. You couldn't go to the beaches. They had barb wires in the water . . . We just know that when you parents tell you get home, you get home and you wait till when it's daybreak," says LeiIlima Joy.

What emerges from the oral histories is a sense of Waikīkī as a community. Many of the interviewees remember their childhoods in Waikīkī as being part of a big, extended family. "In the old days when you saw three or four cars parked on Kalākaua Avenue you'd say, 'Oh somebody's giving a party.' So you'd just drop in and everyone was welcome in old Hawaiian style," remembers Leslie Fullard-Leo.

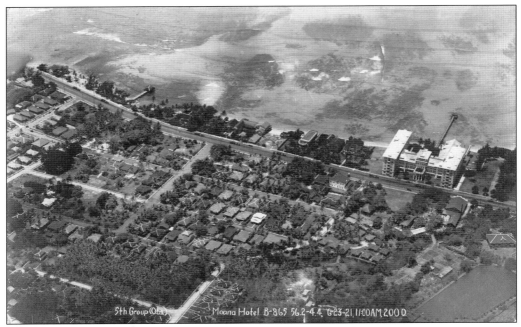

This 1921 aerial photograph shows the neighborhoods surrounding the Moana Hotel. Interviewee Harold Aoki and his older sister were born in one of the small cottages across the street from the hotel, with the aid of a Japanese midwife, or *samba-san*. The family lived in the cottages while Niro Aoki, Harold's father, was a waiter at the hotel. Harold's mother Mizuno raised ducks and chickens and did laundry to make extra money. (Courtesy U.S. Army Museum of Hawai'i.)

Mervin Richards stands in front of his family's home on Hamohamo Road (now Kūhiō avenue) in 1923. The Richards family bought the home from Harold B. Castle on the 5,000-square-foot lot in 1920 for only $2,500. They held *lū'au* in the spacious backyard for the tourists Richards's father met while working as a tour driver. (Courtesy Mervin Richards.)

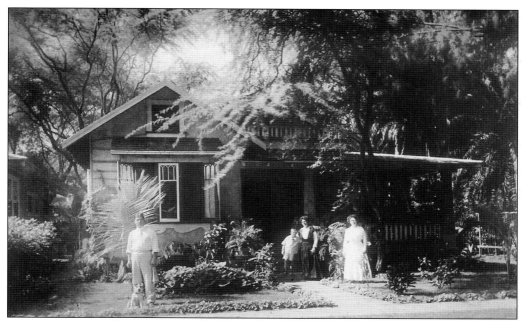

Leslie Fullard-Leo (center), age seven, stands with his family at their home on Kaʻiulani Avenue and Prince Edward Street in 1916. The home was built by his father, a building contractor, in 1915 and was the first stucco home in Waikīkī. The original house was razed in 1969 due to termite damage. (Courtesy Leslie Fullard-Leo.)

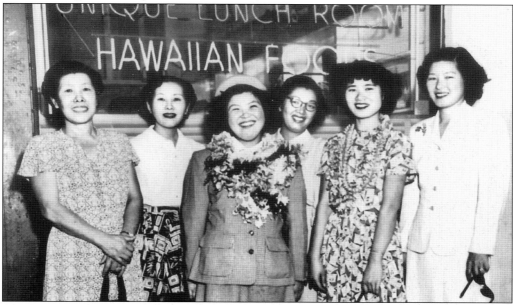

A group of unidentified women stand in front of Sakazo Fujika's Unique Lunch Room on Kalākaua Avenue around 1935. Fujika's daughter, Helen Kusunoki, remembers her father, who immigrated to Hawaiʻi from Hiroshima, Japan, in 1910, as a plantation laborer who "started out small, and when people found out that he [served] Hawaiian food, the demand got bigger and bigger." (Courtesy Helen Kusunoki.)

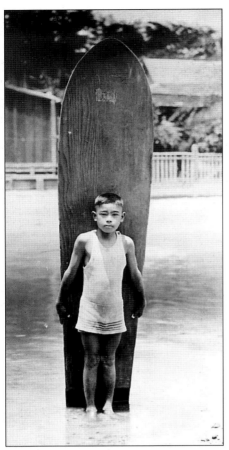

Harold Aoki stands in Hamohamo Stream *c.* 1920 with a homemade surfboard. Surfboards during this period were usually made of imported redwood boards, which were shaped with saw and plane then sanded and varnished. Aoki would surf in front of his family's store on Kalākaua Avenue, near Paoakalani and ʻŌhua Avenues. (Courtesy Harold Aoki.)

The original Aoki store opened in 1913 and was run by Japanese immigrants Niro and Mizuno Aoki. The Aokis and their nine children lived in a one-bedroom dwelling attached to the back of the store. The Aoki store sold everything from tobacco, bread, milk, and vegetables to gasoline, kerosene, and oil. In 1935, the store moved from its original location shown here at Paoakalani and Kalākaua Avenues to the corner of Kalākaua and ʻŌhua Avenues. (Courtesy Harold Aoki.)

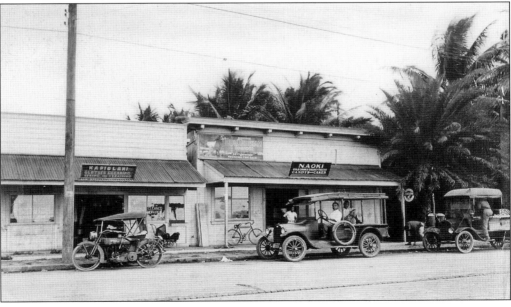

Clarke Paoa, the cousin of Duke Kahanamoku, stands in the driveway of his family's home in the Kālia area in 1947. The road behind Paoa is almost unrecognizable as today's Ala Moana Boulevard. The Paoa family sold their Kālia landholdings in the 1950s. The Hilton Hawaiian Village stands on this site today. (Courtesy Clarke Paoa.)

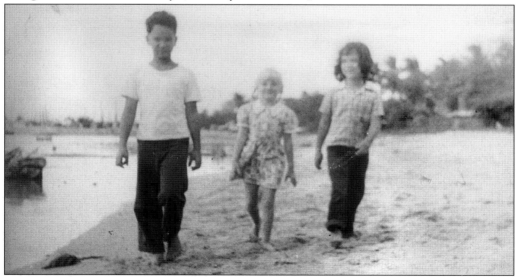

In 1947, Clarke Paoa (left) and two unidentified children walk barefoot along Waikīkī Beach close to the present site of the Ilikai Hotel. Interviewee Fred Paoa, Clarke's brother, remembers their mother used to speak Hawaiian to them: "She spoke fluent Hawaiian to us. And we answered in English. We had all the chance to learn (the language)." In his interview, Paoa said he regretted not learning the Hawaiian language. (Courtesy Clarke Paoa.)

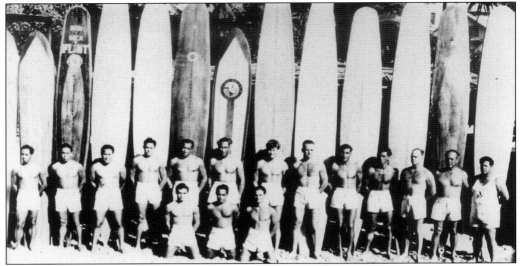

John Ernstberg (far left) stands with the Outrigger Canoe Club's Beach Patrol in 1936. Ernstberg, born in Maui in 1910, grew up in Kapahulu and spent much of his childhood and youth on the beach in Waikīkī. He began earning his living as a beachboy at 17, when his mother died. In 1937, he joined the City and County as a lifeguard at the natatorium, where he stayed until his retirement in 1972. (Courtesy John Ernstberg.)

Employees of the Halekūlani Hotel, one of Waikīkī's most exclusive, stand behind owners Richard "Kingie" Kimball (seated second from left), Juliet Kimball (seated center), and George Kimball (seated second from right) in the 1950s. The Kimballs ran the hotel from 1917 to 1962. John Yonenaga Arashiro (standing, second from left) worked at the hotel as a waiter for 36 years. He worked at all three of the big Waikīkī hotels, including the Moana, the Royal, and the Halekūlani, where he rose to headwaiter in 1946. (Courtesy John Arashiro.)

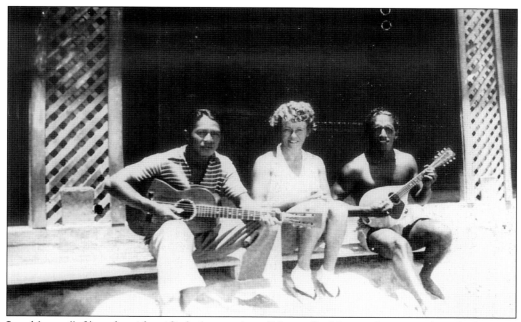

Joe Akana (left) and unidentified play music at Moana Bathhouse for an unidentified tourist about 1930. Akana recalls Sunday nights at the pier, where the beachboys would gather and play music: "you never heard anybody sing until you hear the old beachboys. Those guys had voices, real good voices." (Courtesy Joe Akana.)

Joe Akana, right, and John D. Kaupiko sit on Moana Pier in 1929. Akana was born on 'Ōhua Lane in Waikīkī in 1907. He attended Waikīkī Elementary and later attended McKinley High School but did not graduate. Instead he became a Waikīkī beachboy. In his own words, "the place to be was at the beach. Surfboard instruction, swimming, canoeing—taking people out in the canoe. Could make as much as five dollars a day. Oh, boy, was that big money." (Courtesy Joe Akana.)

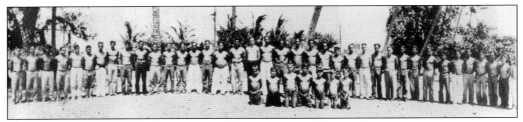

The Stonewall Gang, seen here about 1935, was a group of boys and young men who frequented the "stonewall" area near what is now Kūhiō Beach. They were sports rivals of the Hui Nalu, centered near the Moana Hotel. The Stonewall Gang also included a number of excellent musicians, including the famous Kalima brothers. (Courtesy Jack Bishaw and Ethel Valente.)

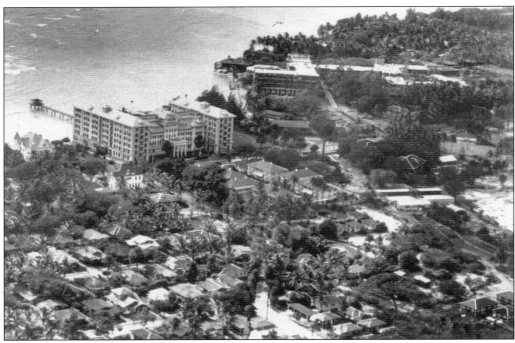

This photograph captures two significant aspects of the late 1920s for Waikīkī's local residents. The first is the construction of the Royal Hawaiian Hotel (upper right). The remnant of the ʻĀpuakēhau Stream is also visible on the right, winding its way beneath Kalākaua Avenue toward the intersection between the Moana Hotel and the vestiges of Helumoa. (Courtesy Vince Sortino.)

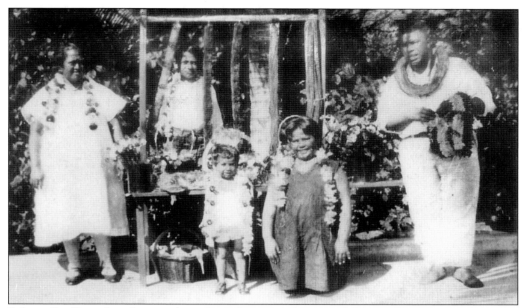

Lilinoe Sniffen is kneeling on the right with parents Annie and George Kepoo at their Waikīkī *lei* stand in front of the Royal Hawaiian Hotel. They operated this stand from 1927 until 1933 and sold plumeria *lei* for 50¢ and carnation and *pikake* for $1.50. The family had to move their business three times due to construction in Waikīkī. Later they owned a truck that they parked along Kalākaua Avenue from 1933 to 1960. (Courtesy Lilinoe Sniffen.)

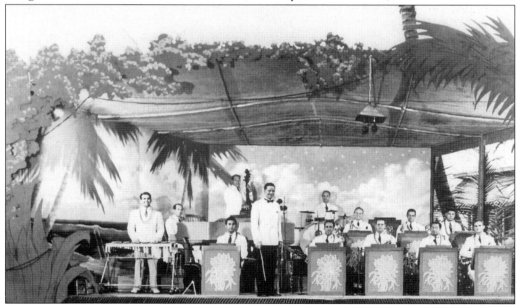

Benny Kalama is seated third from the left with Malcolm Beelby and the Royal Hawaiian Orchestra at the Royal Hawaiian Hotel ocean stage some time in the 1930s. Kalama began playing the trombone in the band at Kalākaua Intermediate School in 1931. According to Kalama, his ability to read music, not just play by ear as many Hawaiians did, got him work with the bigger bands. (Courtesy Benny Kalama.)

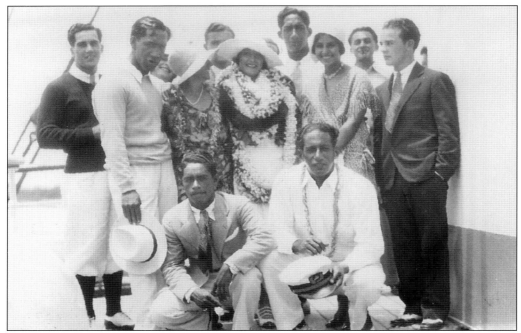

Joe Akana (kneeling left) and two of the Kahanamoku brothers, Louis (second from left) and Sarge (fourth from right) stand with a group of unidentified tourists on a ship, probably departing the islands, about 1930. Akana and the Kahanamokus likely entertained the visitors for a week or more with music, surfing or canoeing lessons, and maybe even a *lūʻau* at the Kahanamoku residence in Kālia. (Courtesy Joe Akana.)

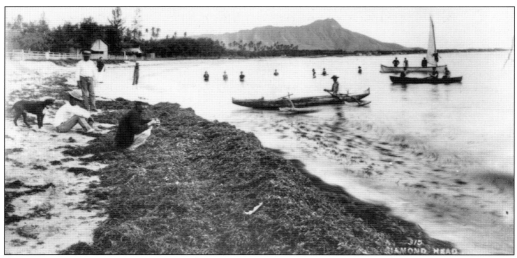

Fred Paoa, another Kālia resident, remembers picking and eating *limuʻeleʻele*. "That's the name of the type of *limu* [seaweed] you find near a stream entering into salt water," Paoa said. He added that *limuʻeleʻele* was eaten with stew and lamented that it was no longer found in Waikīkī. In this late-19th-century photograph, various types of *limu*, probably including the *limu lipoa* variety found closer to shore, are abundantly heaped on the sand. (Courtesy Hawaiʻi State Archives.)

Nine

BIRTHPLACE OF A MODERN PASTIME

EXPORTING SURFING TO THE WORLD

The Hawaiian expression for surfing is *he'e nalu*, where *he'e* means to slip or slide and *nalu* means wave or surf. It is clear that in traditional times surfing was widely practiced throughout Hawai'i and that it was intrinsic to Hawaiians' spiritual relationship to the sea. Both Kamehameha the Great and Queen Ka'ahumanu were excellent surfers and were known to have surfed in Waikīkī after moving there in 1795.

From ancient Hawaiian chants, as well as from the writings of the earliest Europeans, we know that surfing was practiced at the level of sacred art and national pastime. When the waves were good, William Ellis wrote in 1831, "the thatch houses of a whole community stood empty" as everyone abandoned daily tasks to play in the surf.

In the 19th century, because some missionaries discouraged surfing and also because of the dramatic reduction in the native Hawaiian population due to disease, surfing went into decline. During this period, Waikīkī was one of the few places where it was still practiced. Among the notable surfers of the late 19th century was Princess Ka'iulani, who is known to have surfed regularly in Waikīkī.

In the early 20th century, as surfers from Waikīkī traveled to the mainland United States, the sport gained in national popularity. George Freeth, who in 1907 taught novelist Jack London about surfing in Waikīkī, left Hawai'i later that year to give surfing demonstrations in California. He settled in Huntington Beach, California, where he became California's first beach lifeguard.

But it was Duke Kahanamoku who is generally regarded as the grandfather of modern surfing. Born in 1890 in the Kālia neighborhood of Waikīkī, he became a national—then international—celebrity because of his success as an Olympic swimmer. As a surfer, he was among the first to ride the larger waves that sometimes break in Waikīkī. Today, a 17-foot statue of Kahanamoku stands next to Kalākaua Avenue at Kūhīo Beach.

Until the 1950s, when changes in surfboard design and construction allowed surfers to ride the much larger waves found at Makaha and on O'ahu's North Shore, Waikīkī remained the center of surfing, both locally and internationally. For many surfers today, surfing is still done as a mode of connecting to the larger and more spiritually significant aspects of nature. And many acknowledge Waikīkī as the place where modern surfing began.

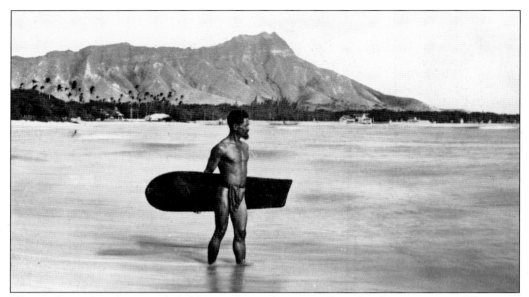

The surfer in this photograph holds a traditional *alaia* surfboard and wears a *malo*. The *alaia*, made of breadfruit or *koa*, was the shorter of the two traditional surfboard shapes. The other type, called the *olo*, was sometimes up to 18 feet in length. Both were made of wood, but the longer *olo*, which was reserved for chiefs, was made of the much lighter *wiliwili*. (Courtesy Hawai'i State Archives.)

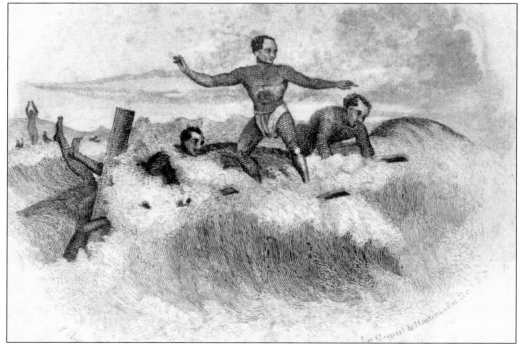

William Ellis, an early missionary and ethnographer, created this etching. Westerners were astounded at Hawaiians' abilities at both surfing and swimming. Originally published in Ellis's *Polynesian Researches*, the etching was likely done in 1824. (Courtesy Hawai'i State Archives.)

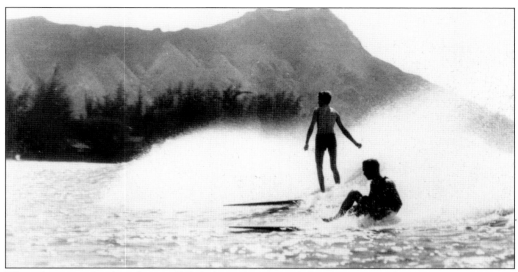

This photograph of surfing in Waikīkī is dated 1915. In this era, surfers would ride boards made of solid wood. The waves in Waikīkī are generally only suitable for surfing during the summer months, as Southern Hemisphere winter storms generate the waves. (Courtesy Hawai'i State Archives.)

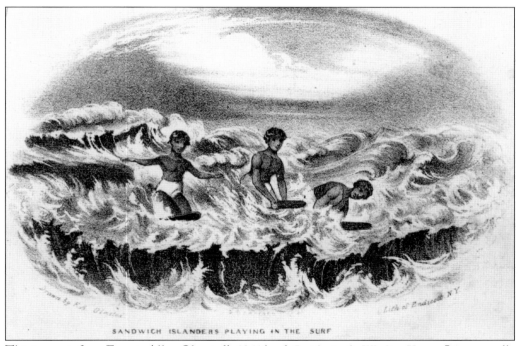

SANDWICH ISLANDERS PLAYING IN THE SURF

This image is from Francis Allyn Olmsted's 1841 book *Incidents of a Whaling Voyage*. It is generally believed that in traditional times, Hawaiians of all ages and both sexes surfed whenever wave conditions permitted. Legends and chants also describe surfing exploits as romantic, as when a man and a woman rode the same wave together. (Courtesy Hawai'i State Archives.)

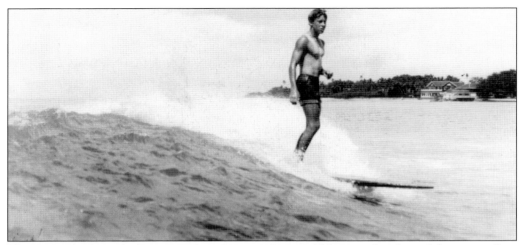

This 1910 photograph shows a surfer riding in what would be considered good form even for a modern longboard surfer. In 1910, though, surfboards had no fins on the bottom, which made this sort of angling across the unbroken face of a wave extremely difficult. (Courtesy Hawai'i State Archives.)

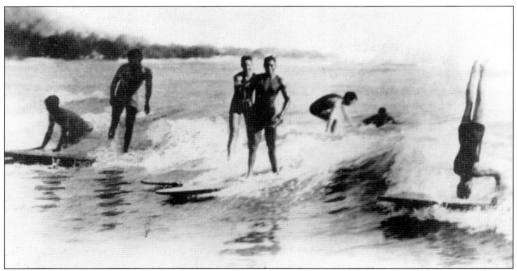

The surfing headstand is of course a difficult maneuver and is still performed occasionally by modern surfers, even in big surf. Such acrobatic moves came to be known later as "hot dogging," because they did not involve the functional aspects of wave riding, like turning quickly or efficiently trimming the board. (Courtesy Hawai'i State Archives.)

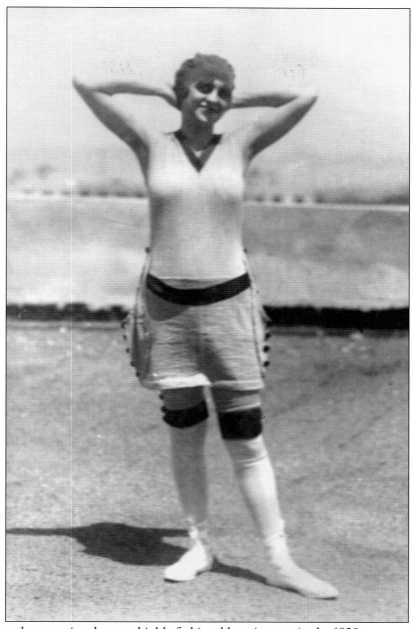

A stockinged woman in what was highly fashionable swimwear in the 1920s poses on Waikīkī Beach. She would have likely swum in her footwear and probably met eyes with many of the local beachboys, and she might have had a surfing lesson or *lomi lomi* (Hawaiian-style massage) with one of them. Although today, we might think such bathing attire overly modest, in the 1920s it was considered quite revealing, if not provocative. The shorts-style bottoms were considered more appropriate for men's bathing suits. In fact, conservative women still wore the heavier bloomer-style bathing costumes with sleeved tops in addition to stockings underneath. Bathing etiquette standards of the day do not seem to have hindered this woman's self-expression, at least not for the camera! (Courtesy Hawai'i State Archives.)

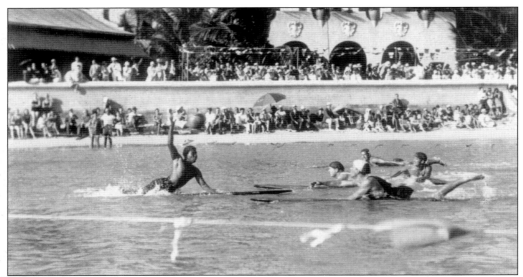

This surfboard water polo game took place next to the Royal Hawaiian Hotel in the early 1930s. Originally the idea of Louis Kahanamoku, the game was also played in Southern California and at Jones Beach in New York. With seven players on each side, the object was the same as in water polo: to put the ball through the opposing team's goal. The playing area was 50 to 100 yards long and 25 yards wide. The game was played with a water polo ball; players stayed on their surfboards and carried the ball under their chins. Kahanamoku recalls, "If you got two guys coming down for you . . . naturally you not going to hold onto the ball. So you look around . . . You throw the ball." (Both courtesy Hawai'i State Archives.)

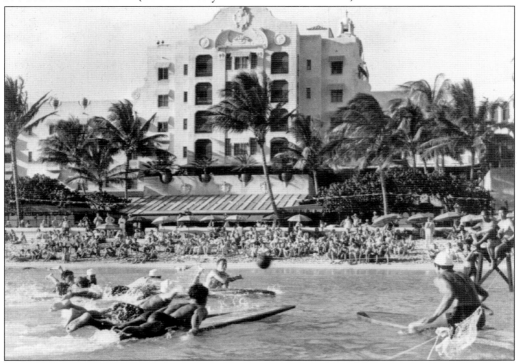

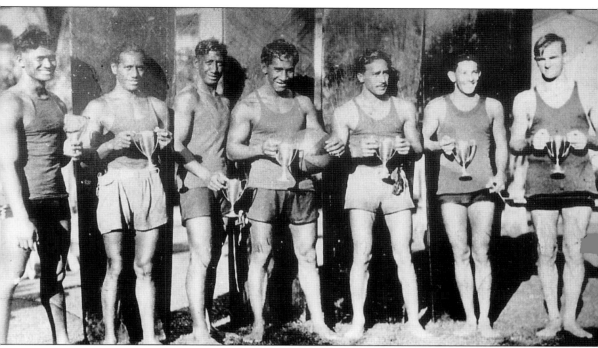

Shown here *c.* 1930 are members of the Hui Nalu Surfboard Polo Team. From left to right, they are John D. Kaupiko, unidentified, Sargent and Louis Kahanamoku, Fred Paoa, Tommy Kekona, and Fred Steere. *Hui* in Hawaiian means club and *nalu* means wave; thus, Hui Nalu was a club devoted to ocean sports. On the occasion of this photograph, Hui Nalu had doubtless been victorious over its rival, the Outrigger Canoe Club. Hui Nalu was founded in 1908 by Duke Kahanamoku and during its early years met under the *hau* trees along the beach next to the Moana Hotel. Both clubs had the common goal of promoting Hawaiian ocean sports; however, they differed in that Outrigger members were mostly Caucasian and Hui Nalu members were mostly Hawaiian. Most of the early beachboys came from Hui Nalu. Both Outrigger and Hui Nalu have continued to function over the years, and their early rivalry in canoe racing has been an important factor in its immense popularity today. (Courtesy Fred Paoa.)

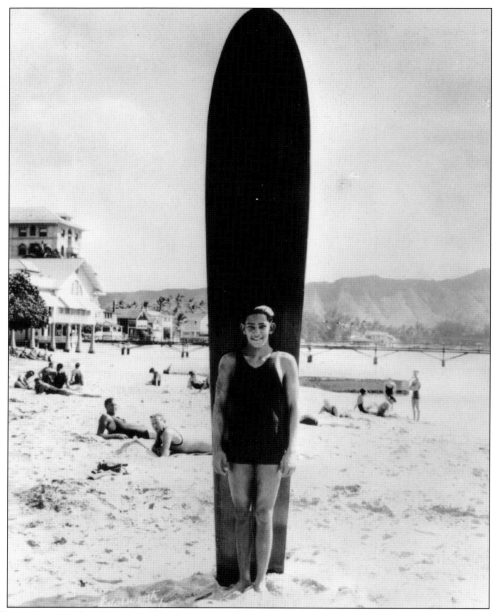

This photograph of Tommy Kekona in 1925 shows the young surfer with his wooden-plank surfboard. This general type of fin-less surfboard was standard equipment in Waikīkī from ancient times. By the time of this photograph, plank surfboards were made from redwood being imported to the islands for the construction of homes and other buildings. The particularly wide planks needed for surfboards were also used in the construction of *furo*-style Japanese baths. The outline cut of the plank was made with a saw. Draw-knife, hand planer, and sand paper were used to fine-tune the contours of the board, and varnish was used for the finish. In the late 1930s, John Kelly and Wally Froiseth developed the "hot curl" design, which had a narrow tail and allowed surfers to maneuver into tighter angles across the wave face. Consequently surfers could ride at much higher speeds and on much larger waves. (Courtesy Hawai'i State Archives.)

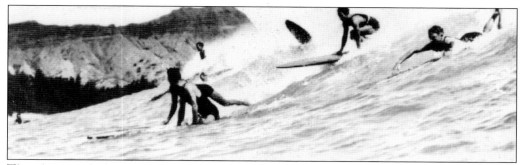

This photograph shows surfers in various stages of taking off on a wave, while one remains sitting on his board letting the others pass. In order to ride a wave, the surfer must paddle fast enough to allow the board to "catch" the wave, at which time the surfer jumps to his feet. (Courtesy Hawai'i State Archives.)

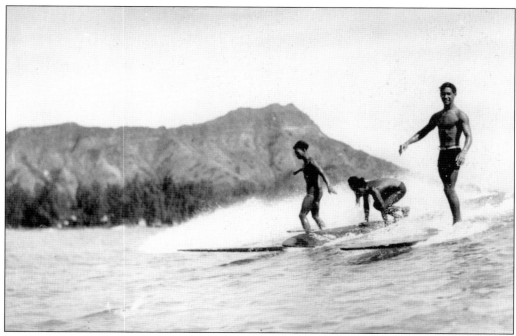

In this 1950s photograph, the surfer in the foreground shows exceedingly good form, relaxed with his hands held palms down, and of course smiling. The surfer in the middle maneuvers for a good trajectory across the wave as he moves into a standing position. In the background, the surfer standing is accelerating very fast, yet his form is good, as his weight is distributed evenly over his two legs. (Courtesy Hawai'i State Archives.)

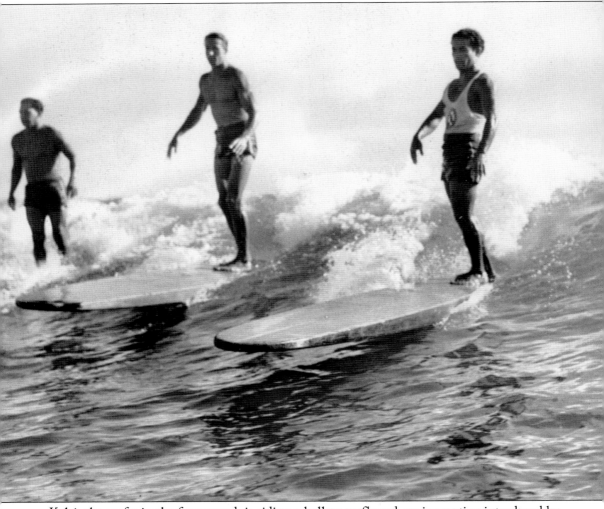

Kalei, the surfer in the foreground, is riding a hollow surfboard, an innovation introduced by surfboard designer Tom Blake in the 1930s. Blake was originally from the American Midwest and was inspired by Duke Kahanamoku to take up competitive swimming and surfing. He soon moved to Waikīkī, where he quickly established himself as an accomplished waterman. He spent much of the rest of his life designing surfboards, paddleboards, and other watercraft, living part-time in Hawai'i and part-time in California. He also wrote books on surfing and lifesaving, as well as articles about surfboards for *Popular Mechanics* and *Popular Science*. Hollow boards were about half the weight of traditional plank surfboards and were much easier to paddle. By the mid-1950s, both plank and hollow boards had been replaced by balsa and fiberglass boards with fins, and surfing had begun to gain popularity outside Waikīkī, particularly at Makaha on the west side of O'ahu, as well as in California and Australia. (Courtesy Hawai'i State Archives.)

Tom Blake paddles a proto-sailboard in the mid-1930s. Sailboarding took off as a sport in the 1970s, after inventors refined the manner of connecting the mast to the board, allowing the rider to stand while holding a boom that controlled the mast and sail. In the background is Kūhiō Beach. (Courtesy Hawai'i State Archives.)

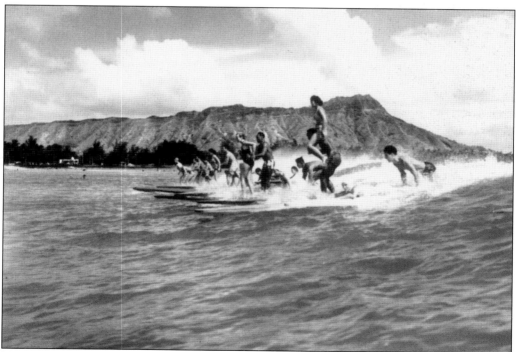

Tandem surfing became popular in Waikīkī as surfing instruction became more commonplace, and partnerships involving strength, surfing skill, and a certain acrobatic ability began to form. This photograph was taken in the early 1950s, when the very large surfboards needed to float two people were widely available. (Courtesy Hawai'i State Archives.)

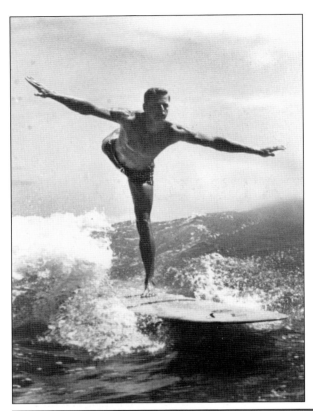

The 1950s brought major innovations in surfboard design, as balsa wood and fiberglass boards with fins became much lighter. This made surfboards much more stable. Here, Paul Dolan demonstrates a kind of surfing arabesque. (Courtesy Paul Dolan.)

Improved stability also increased the popularity of tandem surfing, as Paul Dolan and partner Lee Ann Ferguson demonstrate. The surfers catch a wave considerably before it breaks, then both quickly stand before executing the lift. Remaining in the tandem pose while riding the turbulent whitewater is extremely challenging. (Courtesy Paul Dolan.)

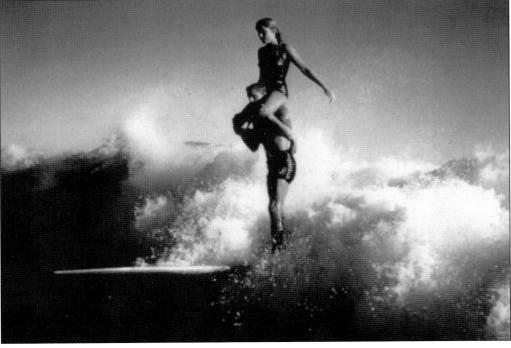

Ten

World War II and Statehood

Prelude to Mass Tourism

December 7, 1941, was a day well remembered in Waikīkī. One explosion, likely from an anti-aircraft shell, occurred at the corner of Lewers Street and Kūhīo Avenue. Luckily there were no injuries. But the bombing of Pearl Harbor and the threat of further attack transformed Waikīkī into a fortress.

Prior to World War II, there was already a strong military presence in Waikīkī, including two military installations: Fort DeRussy and Fort Ruger. But after the Pearl Harbor attack, the military also took over the two major hotels, the Moana and the Royal Hawaiian, and lined the shore with barbed wire. Surfing was forbidden and informal gatherings during the evening at the beach were also outlawed.

As elsewhere in the United States, Waikīkī residents took war-related jobs and joined the military. When the war ended, there was a rapidly increasing demand for hotel rooms as well as inexpensive apartments. By 1947, some of the elegant beachfront homes near Kūhīo Beach had been bought and demolished to make space for more hotels. In 1951, the city and county government began implementing a new master plan. The plan called for the condemnation of a small number of beachfront properties to make way for parks. And in the several blocks between Kalākaua Avenue and the Ala Wai Canal, an increasing number of larger apartment buildings began to appear. Construction on the first of these, the 12-story Rosalei Apartments, began in 1953.

By 1960, Hawai'i had become the 50th state, and land values in Waikīkī were skyrocketing. Properties that had been bought in the 1920s and 1930s for under $50,000 were selling for millions in 1959. Matson sold its hotels (including both the Moana and the Royal Hawaiian) to Sheraton Corporation of America, which in turn sold them to a Japanese group headed by Kenji Osano. By this time, there were nearly 300,000 visitors a year.

In the years since statehood, Waikīkī has become a destination for over 72,000 tourists a day. But it has also remained a community where just under 20,000 people claimed annual residency in the year 2000. The roots of this community reach down below the concrete towers to the fresh water that still bubbles up in Kapi'olani Park. The memory of agriculture is in the soil. And the memory of Waikīkī as a place of hospitality and healing remains in the stories and images of the people and the landscape that knew the "place of spouting waters" before it was transformed.

A sign advertises Stovall's Boat Shop, offering deep-sea fishing tours, boats for hire, yacht brokerage, and marine repair. The location of this humble entrance to the ocean was in the Kālia area of Waikīkī, near the present day Hilton Hawaiian Village. (Courtesy Hawai'i State Archives.)

This post–Ala Wai Canal photograph from the 1950s shows some local children playing baseball in the fields adjacent to the canal. Prior to the creation of the Ala Wai Canal, this area was mostly used for wetland agriculture. In the years since statehood, high-rise apartments and hotels have replaced most of the landscape captured in this view. (Courtesy Hawai'i State Archives.)

This photograph of the Ala Wai Canal, taken in the early 1950s, reflects some of the more modern recreation that became a part of the canal. The original right-of-way for the canal's construction was an 800-foot-wide, 161-acre parcel that extended from Kapahulu Avenue to Sheridan Street. (Courtesy U.S. Army Museum of Hawai'i.)

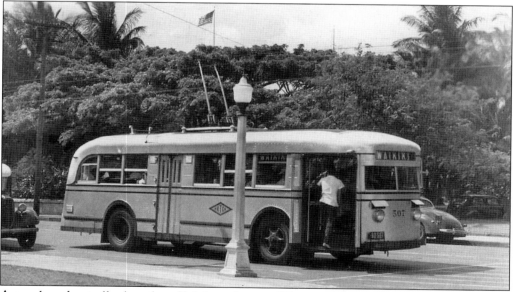

A man boards a trolley bus along Kalākaua Avenue. Electric trolley busses replaced streetcars in 1938 and were in use until 1957, when gas-powered buses, unrestricted by the electric grid, took over. Unlike other cities—for example, San Francisco—Waikīkī's leadership chose not to keep the historic elements of the area's transportation, such as streetcars or trolley buses. (Courtesy U.S. Army Museum of Hawai'i.)

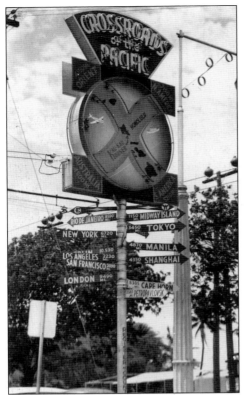

The "Crossroads of the Pacific" sign at the corner of Kalākaua Avenue and Kapiʻolani Boulevard depicted distances from Waikīkī to major world cities and was located where the Hard Rock Café is today. The Kau-Kau (Hawaiian for food) Corner was a popular spot for drive-in (take-out) food. A tiny plane and boat add a cartoonish element to one of the most photographed landmarks outside of Diamond Head in 1930s Waikīkī. (Courtesy U.S. Army Museum of Hawaiʻi.)

Taken just after the end of World War II, this photograph shows Waikīkī Beach crowded with U.S. servicemen enjoying the still-new recreation status of nearby Fort DeRussy. A Hawaiian beachboy holds a surfboard near the shore. The Moana Hotel dining room, which extends over the beach, was demolished in November 1947. (Courtesy U.S. Army Museum of Hawaiʻi.)

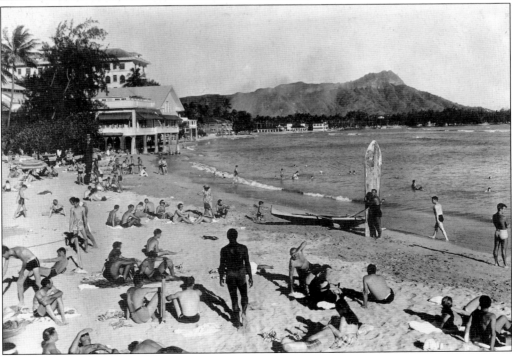

A sleepy, suburbanesque Kūhiō Avenue lined with palms and sidewalks flanked with lawns stretches toward Diamond Head in this 1940s view. Sandwiched between Kalākaua Avenue and the Ala Wai Boulevard, more high-rises than humble homes can be found on Kūhiō Avenue today. (Courtesy U.S. Army Museum of Hawaiʻi.)

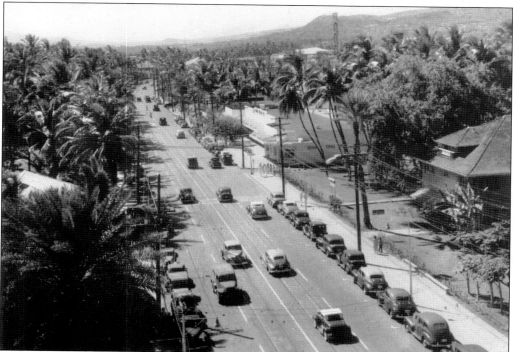

This World War II–era photograph of Kalākaua Avenue captures the Americanization of Waikīkī, with cars parked bumper to bumper and sailors in white uniforms strolling toward Waikīkī Theatre (upper right). The trolley tracks still lining the cement are remnants of the streetcar, still only a decade past. (Courtesy U.S. Army Museum of Hawaiʻi.)

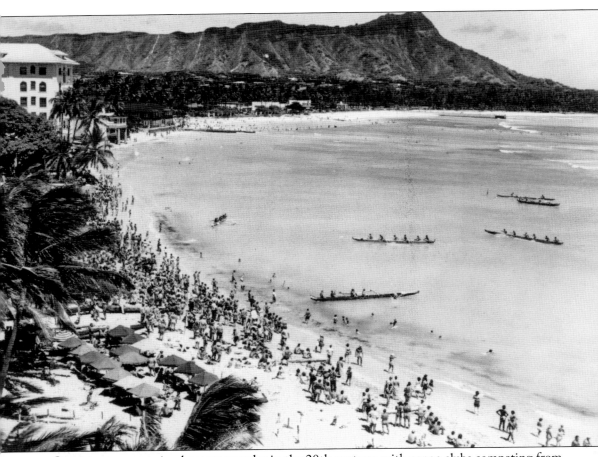

Outrigger canoe racing became popular in the 20th century, with canoe clubs competing from all of the islands as well as the mainland U.S. and other countries. Some of the most important annual outrigger canoe races take place in Waikīkī, including the Mokokaʻi Challenge, where teams paddle a grueling 40 miles, crossing the Kaiwi Channel from the island of Mokokaʻi to Duke Kahanamoku Beach on Oʻahu. Both men and women compete in canoe racing, often training as long as nine months together in preparation for a race as long as the Mokokaʻi Challenge. This photograph shows a race ending near the Moana Hotel. (Courtesy Hawaiʻi State Archives.)

The 25-story Foster Tower is a leasehold condominium located at 2500 Kalākaua Avenue. The building sits on land owned by the Lili'oukalani Trust, beneficiaries of which are destitute and orphaned children of Hawaiian ancestry. The lands owned by Lili'oukalani Trust, like those owned by Bishop Estate and Queens Hospital, were originally owned by prominent 19th-century Hawaiians. These philanthropic trusts remain the largest landowners in Hawai'i. (Courtesy Historic Hawai'i Foundation.)

When the Waikīkī Bowl, shown here in 1960, was demolished to make way for a public-beach park, the four legendary "wizard stones" were discovered in its foundation. Ancient residents of Waikīkī placed the stones on the shoreline to commemorate the work of four Tahitian healers who had lived among them. The stones can be found today at Kūhīo Beach. (Courtesy Historic Hawai'i Foundation.)

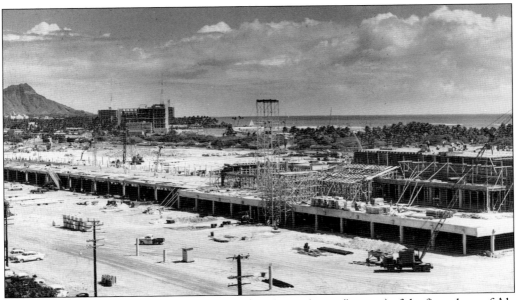

These photographs show the construction (top) and completion (bottom) of the first phase of Ala Moana Shopping Center in the Kālia area of Waikīkī. The shopping center was made possible with the fill from the massive dredging of the Ala Wai Canal and Waikīkī's ocean reefs. When it opened in 1959, the center featured 87 stores and 4,000 parking spaces; it was the largest shopping center in the United States. Although it no longer holds that distinction, it now houses over 260 shops and restaurants and one of the world's largest food courts. It boasts 56 million visitors each year. Visible in the background of the top photograph is the Ilikai Hotel, under construction, another 1950s milestone in Waikīkī's development. The Ilikai was made famous when Jack Lord stood on the rooftop for the opening of the television drama *Hawaii Five-O*. (Both courtesy Hawai'i State Archives.)

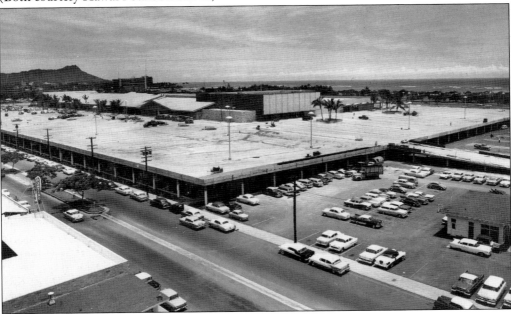

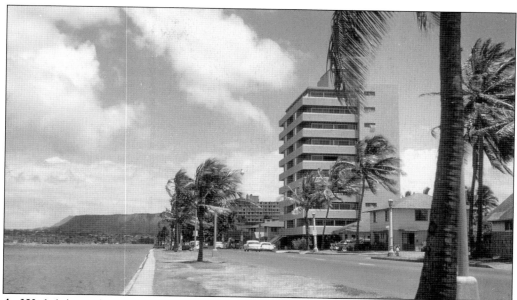

As Waikīkī's residential population increased in the 1960s, Hawaiian bungalow-style cottages began to give way to multistory apartment buildings, which in turn would later give way to high-rises. The Bel Air, shown here, was among the low-rise apartment buildings along the Ala Wai Canal. The single-story home next to the 10-story apartment building contrasts the image of small town with that of the growing city. (Courtesy Historic Hawai'i Foundation.)

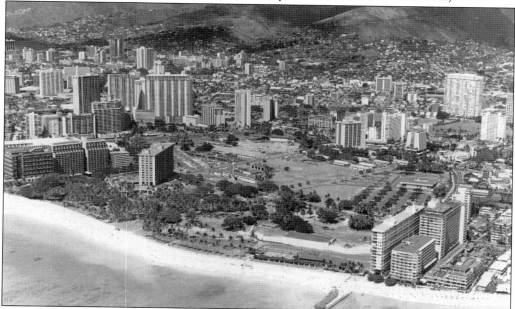

Most of the land that makes up Fort DeRussy was once fishponds. Wetland reclamation in Waikīkī actually began at Fort DeRussy in 1909, when a portion of Waikīkī's ponds were drained and filled. Today the open space surrounding DeRussy's Army Museum and Hale Koa Hotel provide one of the only respites from the urbanized environment Waikīkī has become. (Courtesy Hawai'i State Archives.)

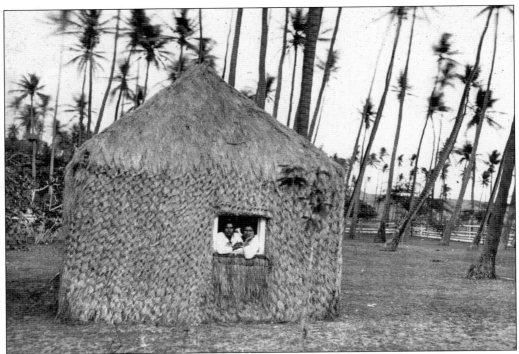

This *hale pili* was probably a re-creation for tourists, but the Hawaiian faces in the window and the palms in the background give it the feeling of early Waikīkī. (Courtesy Hawai'i State Archives.)

This home is part of Diamond Head Terrace Tract, the last subdivision built in Waikīkī prior to the reclamation project of the 1920s. About two miles from downtown Waikīkī, the area was originally served by the electric trolley. The first house in the tract was built in 1925, and the neighborhood remains largely historically intact, boasting eight properties on the National Register of Historic Places. (Courtesy Hawai'i State Archives.)

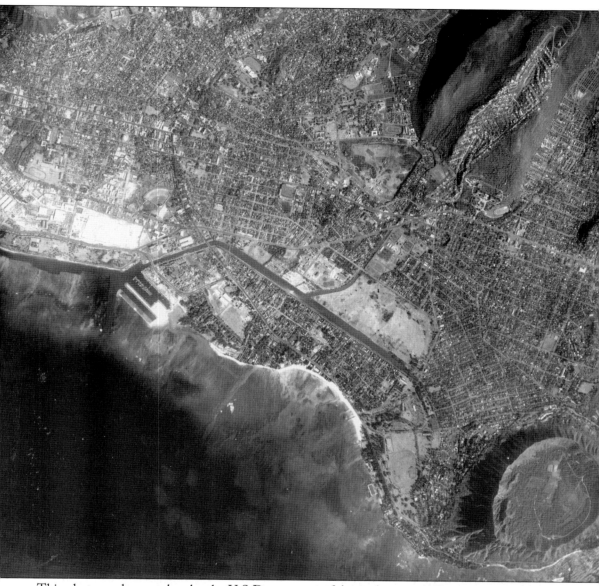

This photograph was taken by the U.S Department of Agriculture in 1952, approximately 30 years after the creation of the Ala Wai Canal. The circular geological feature on the right is Diamond Head Crater. Next to it is Kapiʻolani Park and the natatorium. On the left is the Ala Wai Boat Harbor and a large open space where Ala Moana Shopping Center would soon be built. Across the top are, from right to left, the neighborhoods of Makiki, Mānoa, St. Louis Heights, and Pālolo. The full extent of the development made possible by the various dredging and filling projects of the early 20th century can clearly be seen. Many of the images chosen for this book reflect scenes of Waikīkī prior to development. The intention behind the inclusion of such images is to nurture the memory of what Waikīkī used to be and also to encourage reflection about how the "place of spouting waters" might have been preserved, or at least developed differently, so as to better preserve the past. (Courtesy U.S. Geologic Survey.)

BIBLIOGRAPHY

Center for Oral History. *Waikīkī, 1900–1985: Oral Histories*. Honolulu: Social Science Research Institute, University of Hawai'i at Mānoa, 1985.

Feeser, Andrea and Gaye Chan. *Waikīkī: a History of Forgetting and Remembering*. Honolulu: University Press of Hawai'i, 2006.

Finney, Ben and James D. Houston. *Surfing: A History of the Ancient Hawaiian Sport*. Rohnert Park, CA: Pomegranate Artbooks, 1996.

Fuchs, Lawrence H. *Hawaii Pono: A Social History*. New York: Harcourt, Brace, and World Inc., 1961.

Grant, Glen. *Waikīkī Yesteryear*. Honolulu: Mutual Publishing, 1996.

Hall, Sandra Kimberly and Greg Ambrose. *Memories of Duke: The Legend Comes to Life*. Honolulu: Bess Press, 1995.

Hibbard, Don and David Franzen. *The View from Diamond Head*. Honolulu: Editions Limited, 1986.

Kame'eleihiwa, Lilikalā. *Native Land and Foreign Desires*. Honolulu: Bishop Museum Press, 1992.

Kanahele, George S. *Waikīkī 100 B.C. to 1900 A.D.: An Untold Story*. Honolulu: Queen Emma Foundation, 1995.

Kuykendall, Ralph S. *The Hawaiian Kingdom. Vol. III, 1874–1893*. Honolulu: University of Hawai'i Press, 1967.

Malo, David. *Hawaiian Antiquities (Mo'olelo Hawai'i)*. Honolulu: Bishop Museum Press, 1951.

Nakamura, Barry Seichi. *The Story of Waikīkī and the Reclamation Project*. University of Hawai'i, Manoa, Master's Thesis, May 1979.

Osorio, Jonathan Kay Kamakawiwo'ole. *Dismembering Lāhui: A History of the Hawaiian Nation to 1887*. Honolulu: University of Hawai'i Press, 2002.

Stannard, David. *Before the Horror: The Population of Hawai'i on the Eve of Western Contact*. Honolulu: Social Science Research Institute, University of Hawai'i, 1989.

Timmons, Grady. *Waikīkī Beachboy*. Honolulu: Editions Limited, 1989.

Weyeneth, Robert R. *Kapi'olani Park, a History*. Honolulu: Kapi'olani Park Preservation Society, 2002.

INDEX

Across America, People are Discovering Something Wonderful. Their Heritage.

Arcadia Publishing is the leading local history publisher in the United States. With more than 3,000 titles in print and hundreds of new titles released every year, Arcadia has extensive specialized experience chronicling the history of communities and celebrating America's hidden stories, bringing to life the people, places, and events from the past. To discover the history of other communities across the nation, please visit:

www.arcadiapublishing.com

Customized search tools allow you to find regional history books about the town where you grew up, the cities where your friends and family live, the town where your parents met, or even that retirement spot you've been dreaming about.